IMAGES
of America

BEACHES OF WELLS

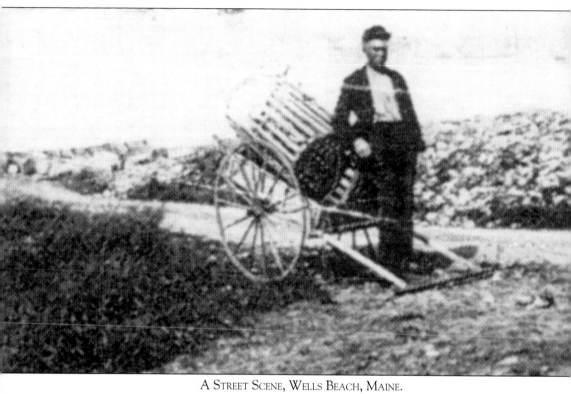

A Street Scene, Wells Beach, Maine.

IMAGES
of America
BEACHES OF WELLS

Hope M. Shelley

ARCADIA
PUBLISHING

Copyright © 1997 by Hope M. Shelley
ISBN 978-0-7385-1257-0

Published by Arcadia Publishing
Charleston, South Carolina

Printed in the United States of America

Library of Congress Catalog Card Number: Applied for

For all general information contact Arcadia Publishing at:
Telephone 843-853-2070
Fax 843-853-0044
E-mail sales@arcadiapublishing.com
For customer service and orders:
Toll-Free 1-888-313-2665

Visit us on the Internet at www.arcadiapublishing.com

CONTENTS

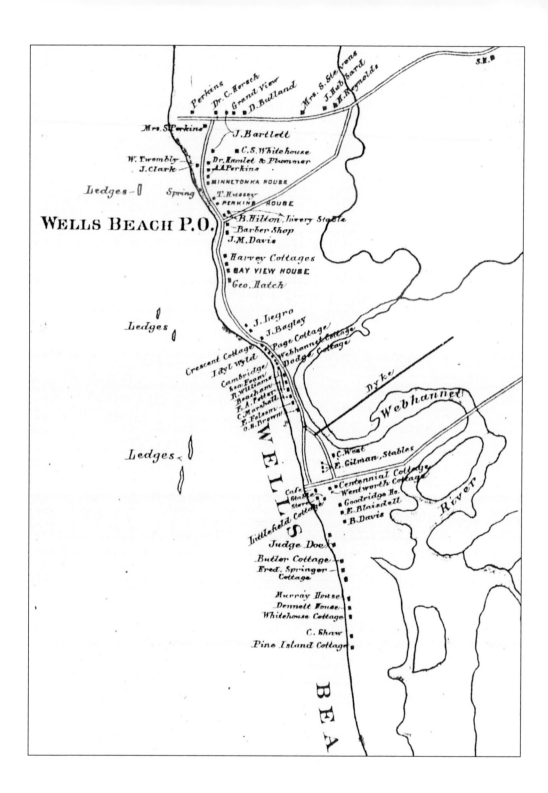

WELLS BEACH P.O.

INTRODUCTION

The beaches of Wells were the natural resource that provided a landing place for the earliest travelers. It is noted by historians that traders and fishermen were using the beaches regularly by the 1500s. In fact, Drakes Island was reportedly named for a Casco Bay trader and voyager, Thomas Drake, who supposedly plied our shores.

As more settlements appeared a century later, these beaches became not only a landing place, but more importantly the highway for travel from one settlement to another. Travel was mostly by foot and allowance had to be made for skirting the rocky ledges with paths through the adjoining forests. It reportedly took two to three days to go from Cape Porpoise to York.

More important still, these barrier beaches were described in deeds as seawalls. This barrier was most important in protecting the marshes from the waters of the Atlantic. The value of the marsh hay with its high mineral content was immeasurable. The survival of the settlers' livestock and subsequently their own depended upon the marsh hay. Any community in New England which had been blessed with marshes had a head-start in maintaining a successful settlement.

The protection of the marshes and the maintenance of the beach barrier was noted in the mid-1700s when the Massachusetts Court (Maine was part of Massachusetts until 1820) wrote a law penalizing anyone who allowed livestock to trample the barrier dunes. In 1757 Province Laws note an act to prevent cattle, horses, and sheep from running at large and feeding on the beach grass at Wells. It further states that the destruction and trampling of such had occurred, thus allowing the seas to break across the beach and cover the said marsh with sand. The penalties were considerable, thus hoping to deter the negligence of the livestock owners.

The Industrial Era of the mid-1800s brought economic prosperity. This and the advances in transportation initiated the development of beach resort towns such as Wells. The arrival of the railroad in 1842, the Atlantic Shore Line in 1907, and eventually the automobile provided accessible means for reaching our shores.

Beginning in the 1850s, wealthy industrialists sought to recreate their social circles at the shore where cooling breezes tempered the heat and humidity of the inland cities. The Atlantic House, built in the 1850s at Fishermen's Cove, was the first such enterprise locally. Interrupted by the Civil War, the shore's development did not progress until the early 1870s, when the Island Ledge House at Wells Beach was built. After being consumed by fire, these huge lodging and entertainment center undertakings were not again attempted. However, numerous smaller hotels and boardinghouses were built. Developers began purchasing the hillocks and hummocks of the barrier dunes for subdivision into individual house lots. In the late 1880s and throughout

the 1890s, Charles Tibbetts acquired Moody Beach. In the early 1890s William Eaton was the local agent for R.B. Crook and J.B. Brackett, merchants from Berwick, who laid out Atlantic Avenue. In the early 1900s Joseph Eaton subdivided Drakes Island. As the cottage boom evolved, the local shipwright, who had formerly built the sailing vessels, now became the house carpenter. Masons and painters began advertising. Electricians and plumbers advertised as well when, in the early 1900s, electricity and town water became available.

Architecture along the shore was varied but generally numerous windows and porches faced the Atlantic. The first area to be built with summer cottages appears to be the Crescent Beach area north to the main beach. The 1891–92 Cadastral Map of the Beaches of Wells shows fifteen beachfront cottages in this area. There were nine cottages noted on Atlantic Avenue, one at Drakes Island, and none at Moody Beach. The service industry of hotels, restaurants, specialty shops, and entertainment centers evolved to accommodate the seasonal population. The original guests were wealthy folk who stayed the whole summer. Not until after World War II, when the automobile became available to nearly every family, did the length of stay change from the whole summer to a more transient few days to a week. Cabins and motels were built to accommodate this generation of the traveling public.

Regardless of whether visitors to Wells came to enjoy Mother Nature's artistry and weather, for family ties, for health or financial gain, for pleasure, or just because it was the fashionable thing to do, the area's popularity among tourists has continued for more than a century of summers. This sharing of the town's natural resources has had a permanent impact on our seacoast community.

ACKNOWLEDGMENTS

To visualize the beaches of Wells in a composite such as this, one can only attempt to scratch the surface in terms of people, places, and things that might have been photographed. The average person at the turn of the century did not own a camera. Merchants hired photographers to take pictures of their business establishments and other attractions, so postcards are our major pictorial connection to our beach community at the turn of the century. Local photographers Leroy Nason and Lester Kimball did much to preserve the past for us.

Although my collection is quite extensive, for a project such as this I am grateful to the following folks and organizations for sharing their images with me: the Historical Society of Wells and Ogunquit, Eleanor Carberry, Marion Chase, Minnie Drysdale, Janet Fisher, Vander Forbes, Pauline Gittins, Jean Gray, Barbara and Louise Hanson, Bertha and Philip Hilton, Walter Kennedy, Gary Littlefield, Mary Luce, Nadyne MacDonald, Charlotte and Keith Moody, Peter Moody, Charles Seaman, Allan Schwarte, and Hilde Woodward. I give my special thanks to Mary Luce, Peter Moody, and Hilde Woodward, for their assistance in identification of people and places; to Nadyne MacDonald and Charlotte Moody, for their encouragement and suggestions; and to Mona Smith, for her assistance, support, and computer skills.

I ask the indulgence of all for any errors or omissions.

One

DRAKES ISLAND

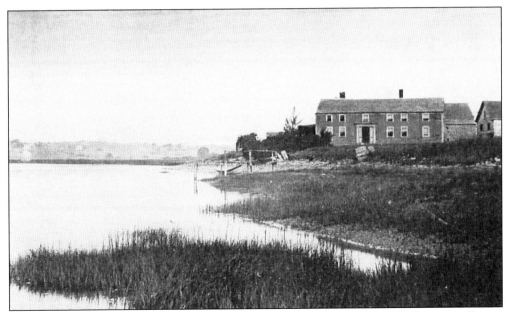

THE WEBHANNET RIVER AT DRAKES ISLAND. The Drakes Island section of Wells reportedly was named for Thomas Drake, an early Casco Bay trader who may have traded here. The building on the right, originally located at the mouth of the river, is believed to have been an early warehouse for local merchants. It was later moved to this location prior to being purchased by the Eaton family.

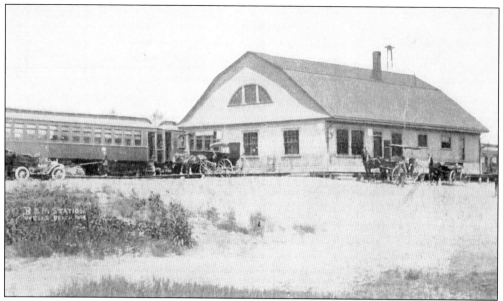

THE WELLS BEACH BOSTON & MAINE RAILROAD STATION. Before the arrival of the automobile, visitors to Drakes Island came here by train. Henry Eaton carried visitors with his buggy and old white horse directly to the island. Eaton met all the trains and was a well-known individual.

STATE BOULEVARD. This 1923 postcard gives yet another name to Post Road. Note the electric car tracks on the right. The small building at the end of Drakes Island Road was used to accommodate folks waiting for the Atlantic Shore Line.

ON THE ROAD TO DRAKES ISLAND. This early-1900s photo shows the sand dunes of Drakes Island. In 1890 Joseph Eaton petitioned the town to build this access to the island. Prior to this, the Beach Road, now known as Laudholm Road, was the only passable way to the island.

SCENIC DRAKES ISLAND ROAD. This road was formerly called the Dyke Road because it crossed the dyke (second bridge). The dyke was installed to control the tidal waters and thus facilitate the haying of the marsh. It washed out in 1915 and was not replaced.

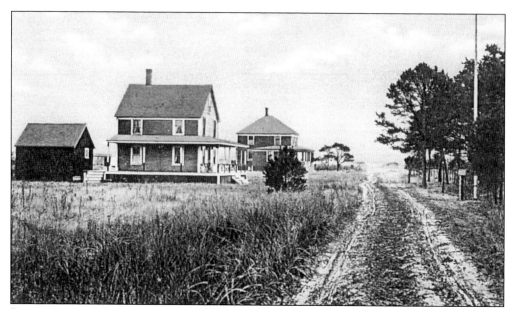

DRAKES ISLAND. This c. 1905 postcard shows the Fassett and Jewell cottages on the left. The wheel ruts through the dune grass is the location of the Drakes Island Road of today. Note the height of the dunes at the end of the street.

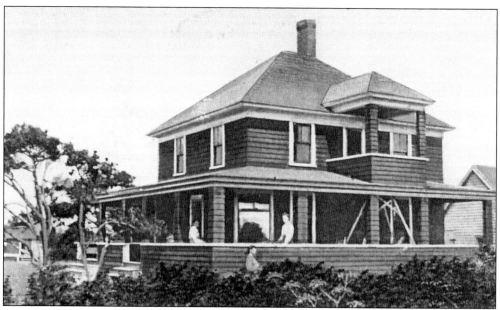

THE PINEHURST COTTAGE, DRAKE'S ISLAND. This 1908 postcard shows the Mary Jewell Lord cottage located on the north corner of the Drakes Island Road and Island Beach Road intersection of today.

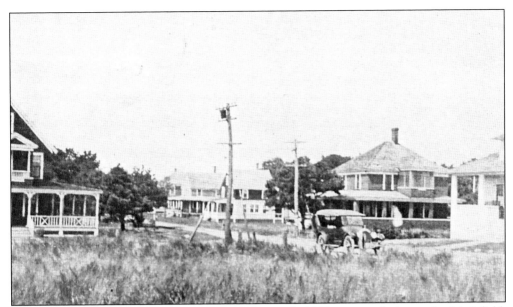

DRAKES ISLAND. Again at the intersection, this early-1900s postcard shows the Littlefield, Fassett, Perkins, and Lord cottages. At about this same time locomotive engineers from the Boston & Maine Railroad were building behind the Littlefield-Bowdoin-Carberry cottage. The engineers' names were Adams, Davis, Small, Woodman, Getchell, and Trefen.

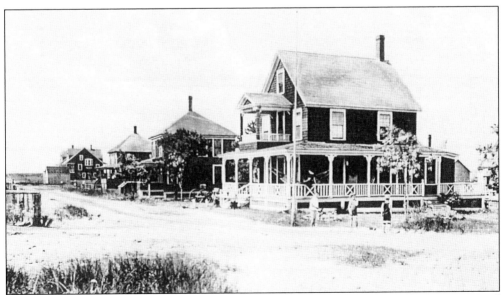

A BACK STREET VIEW, DRAKES ISLAND, LOOKING WEST FROM ENTRANCE ROAD. This 1908 postcard shows the Bowdoin-Carberry cottage on the south corner of the intersection.

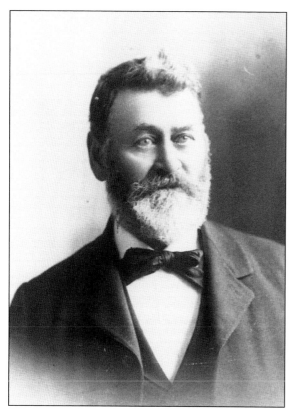

JOSEPH D. EATON (1838–1916). Joseph Eaton was a Civil War veteran who purchased his house and all the land on Drakes Island for $385 in 1883. A civic-minded citizen, he served his town and state in a variety of responsible positions. Eaton built and remodeled homes, and is responsible for developing Drakes Island, beginning in the late 1890s and early 1900s.

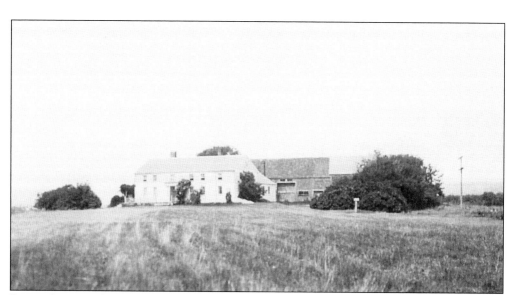

EATON CROFT ON DRAKES ISLAND. This is the land view of the Eaton Farm. Joseph Eaton's home was a showplace with beautiful gardens surrounding it. In the early 1900s it was advertised as a summer hotel in the *Maine Register*. Joseph Eaton's wife was fondly known as Aunt Peggy.

KATE FURBISH (1834–1931). Kate was an amateur botanist who summered at Eaton Croft. She documented several varieties of plants only known to grow locally or in southern York County.

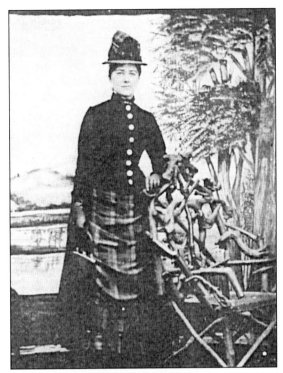

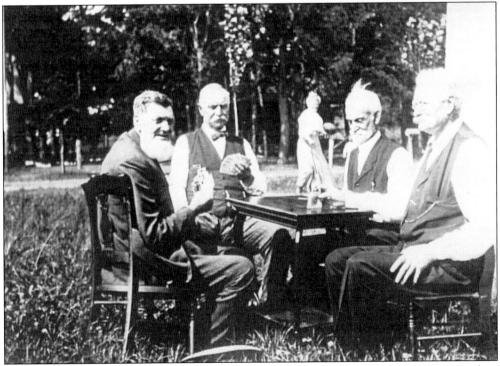

FRIENDS GATHER FOR A CARD GAME. From left to right, Moses Erskine, George Perkins, Stephen Spooner, and John Gillis take advantage of good weather for a game in the yard of the Perkins' cottage, Sunnycroft.

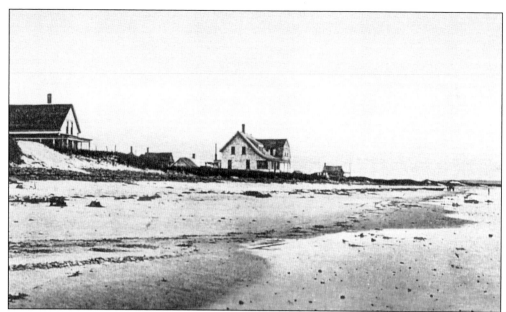

LORD'S BEACH, DRAKES ISLAND. This 1905 postcard shows a few of the approximately twenty-five cottages at the island prior to 1910. "John Salt" Lord purchased land from Joseph Eaton and built the Mildram cottage (the last on right) as well as his own.

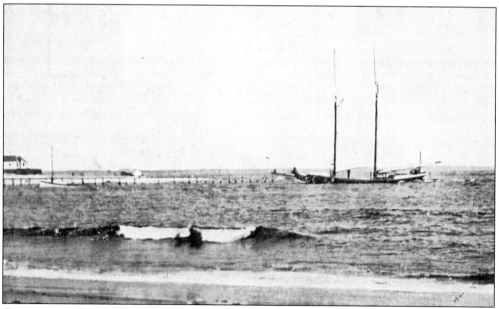

CROSSING THE BAR. The sandbar at the entrance to Wells Harbor limited safe passage for the schooners to only high tide. In 1824 Congress approved $5,000 to build an 800-foot pier to enable vessels to unload outside the entrance. In 1873 crib wood ballasted with stone was again used to help straighten and deepen the channel over the bar. The remains of pilings can be seen in this early-1900s postcard.

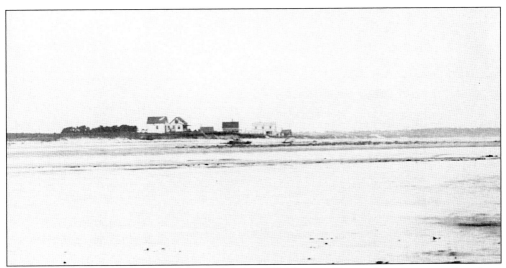

DRAKES ISLAND. Looking across the mouth of the Webhannet River, this view was taken from the Atlantic Avenue side of the beach. The message on this 1907 card states, "Where we often spend the days on the beach. You can see the wreck" (see below). The cottage in the center is probably the Happy Thought, which was moved away from the bluff by the Eatons in early 1900s.

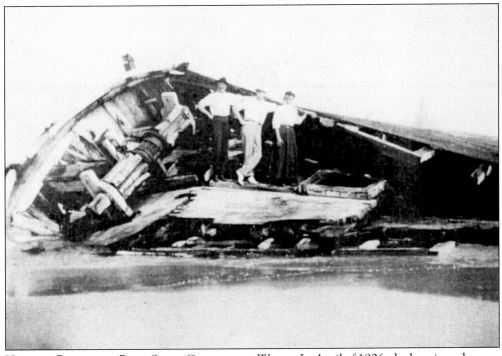

HOWARD, RALPH, AND RUTH SMALL CLIMB ON THE WRECK. In April of 1906, the burning schooner *Rising Sun* laden with lime was beached here by its captain, W.L. Anderson of Boston. The crew escaped and spent the night in the hunter's cabin visible on the bluff in the photograph at the top of the page

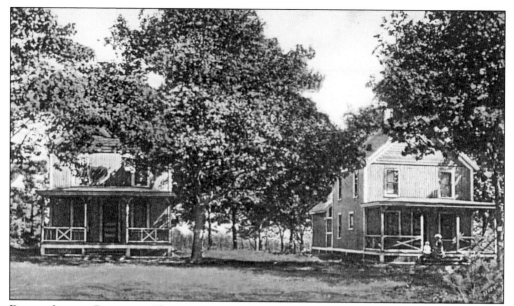

DRAKES ISLAND COTTAGES. The street was called Dyke Road when these cottages were built *c.* 1910. The Restigouche-Murray cottage is on the left, and the Oakdale-Sisson-MacIver cottage is on the right.

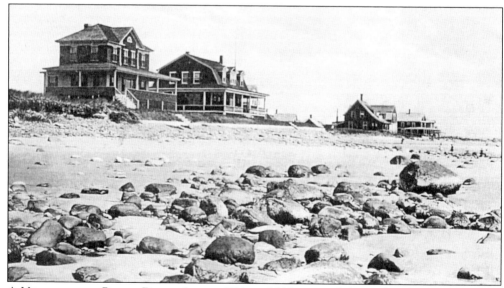

A VIEW FROM THE BEACH, DRAKES ISLAND. This *c.* 1915 postcard shows the Shaw and Banfield cottages. Note the beach stones on the sand.

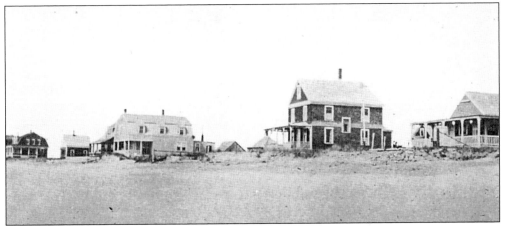

LORD'S BEACH, DRAKES ISLAND. The Haskell, Leech, and Mildram cottages are centered in this c. 1918 scene. The total number of cottages on the island at this time was thirty.

THE MAILMAN AT DRAKES ISLAND. The mailman in this 1910 photograph is unknown. It's likely to have been Bert Wells, who delivered to other sections of Wells at this time.

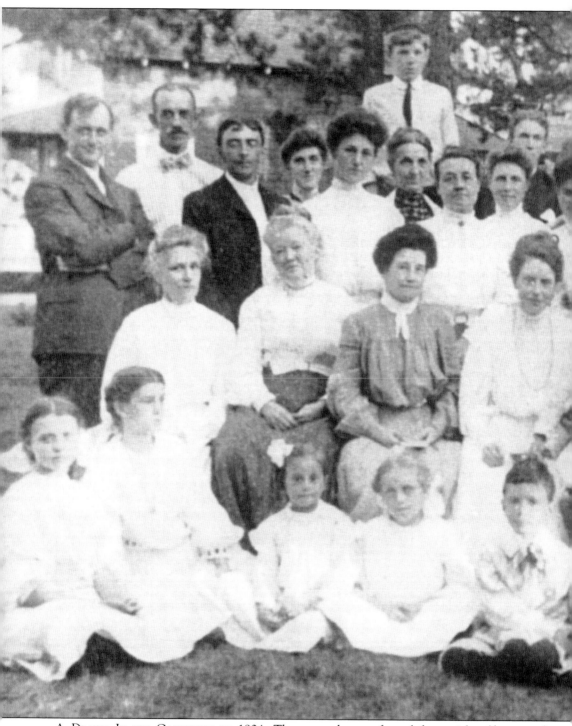

A Drakes Island Gathering in 1904. These people are, from left to right: (front row) Marjorie Wadleigh, Marion Clogston, Peace Warren, unknown, ? Warren, and Herbert W. Malison; (second row) Mrs. Perkins, Mrs. Gillis, unknown, unknown, Elizabeth Dane, Moses Erskine, Stephen Spooner, Lester Eaton, Joe Eaton, and John Gillis; (third row) five unknown

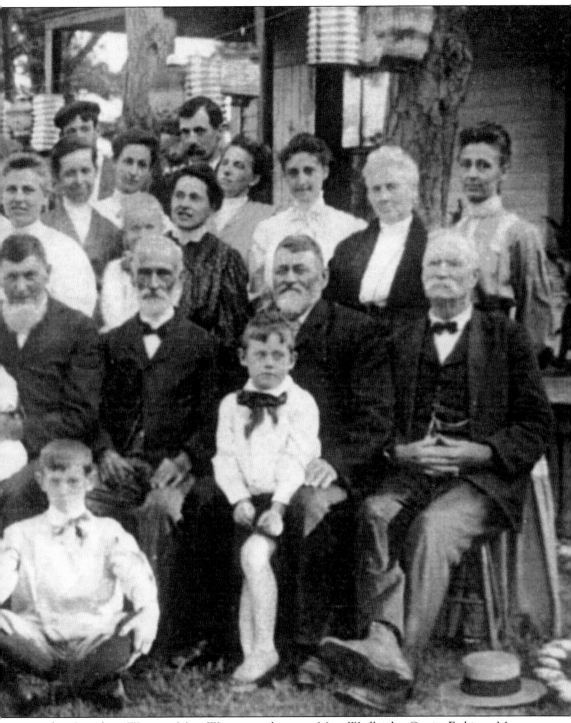

people, Grandma Warren, Mrs. Warren, unknown, Mrs. Wadleigh, Carrie Erskine, Mrs. Dane, unknown, Mrs. Clogston, unknown, Luella Eaton, unknown, Ruth Thayer, unknown, and Abbie Spooner; (back row) Arthur Gillis, Robert Ferris, Tom Bickford, Charles or John Bickford, and Andrew Clogston.

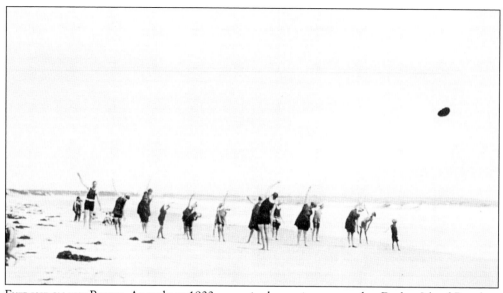

EXERCISE ON THE BEACH. As early as 1922, organized exercise occurred at Drakes Island Beach.

AN UNIDENTIFIED BOY AND HIS DOG AT THE SOUTHERLY EDGE OF THE ISLAND. The Hart's cottage is behind the boy in this 1922 postcard.

ENJOYING THE SURF. The exercisers enjoy the surf following their workout on the beach.

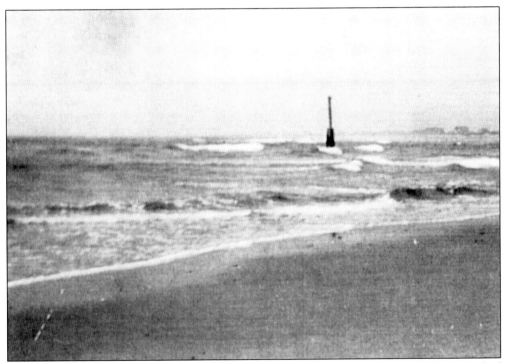

MARKING BUOY. Located at the harbor's entrance at the south end of the island, this buoy marked the sandbar. The 1869 topographical survey notes a large spindle with a pot light at the seaward end of the harbor. The lantern was lit daily at sundown by someone rowing out to the spindle.

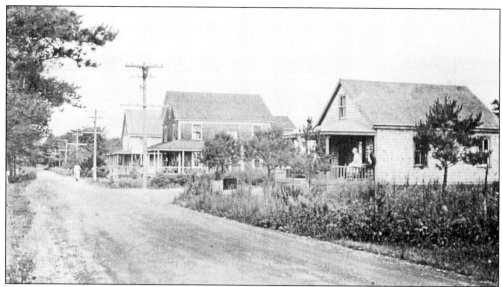

DRAKES ISLAND STORES. All three of these places once served as stores. John Hill opened the first store on the island in 1911; Charles Davis ran the last store on the island in the 1930s and 1940s. He harvested ice from the Skinner & Hobbs Ponds to store in the icehouse out back for use by summer residents. These cottages now belong to the Damon, Gross, and Emerson families.

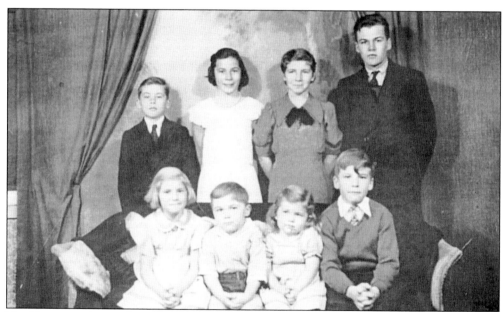

THE FAMILY OF STORE OWNERS CHARLES AND AGNES DAVIS. Charles and Anges Davis owned and operated the store at Drakes Island for twenty-seven years. Mr. Davis was born in Church Stretton, England, in 1897 and came to the United States in 1913. He served with the Army in France during World War I. The Davis children are, from left to right: (front row) Jeannette, Richard, Priscilla, and Robert; (back row) Donald, Dorothy, Eleanor, and Charles Jr.

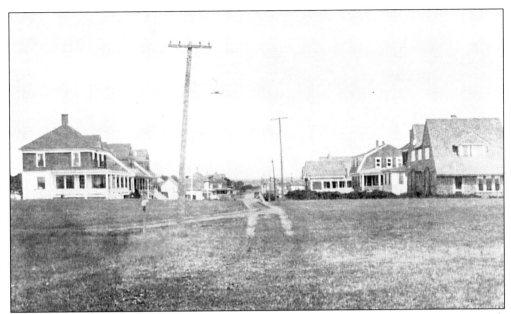

LOOKING NORTH ON THE ISLAND BEACH ROAD. This view shows the road when it wasn't much more than a path. The Evans house is on the left and the Wilson and Conway houses are on the right.

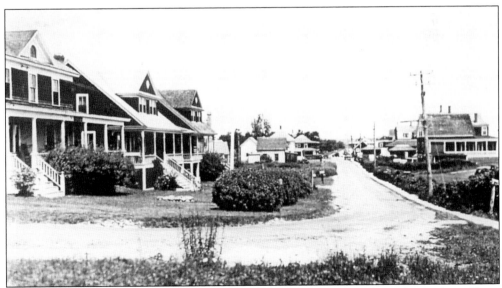

A COTTAGE SCENE AT DRAKES ISLAND. What a difference a decade makes! The road is still not paved, however.

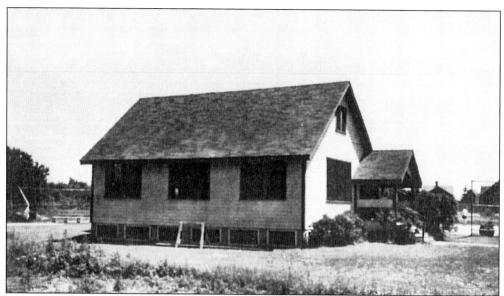

THE COMMUNITY HOUSE AND TENNIS COURTS. Built in 1929, this building increased the recreational facilities for the summer population. The Drakes Island Improvement Society, formed in 1912 with Mr. Gillis as its first president, supervised the facilities.

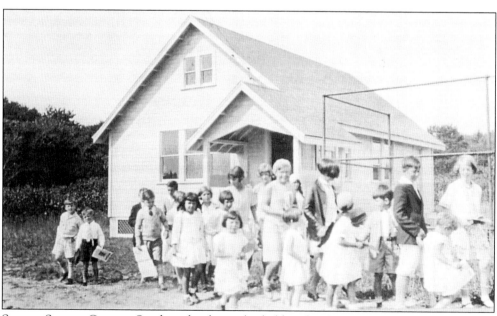

SUNDAY SCHOOL CLASSES. Sunday school was also held at the Community House. An addition was added to the building in 1936.

GOOD TIMES AT DRAKES ISLAND. This 1930s postcard shows the white sands that have beckoned so many folks over the years. By the end of the 1930s, nearly fifty cottages had been built on the island.

THE EARLIEST PLAYGROUND. Located on the southeast corner of Eaton and Grove Streets between the 1930s and 1950s, this playground helped entertain the kiddies when they were tired of the beach.

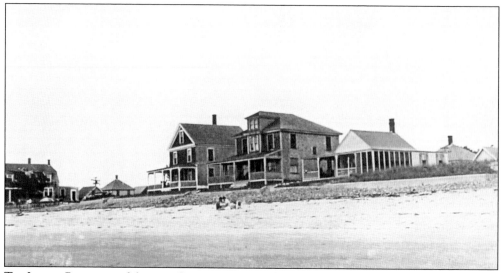

THE LEECH, CURTIS, AND MILDRAM COTTAGES. Located on the north side of the right-of-way to the beach, the Leech and Curtis cottages were destroyed by fire during World War II (see below).

FIRE DESTROYS THREE COTTAGES. These two beachfront cottages were destroyed in the June 30, 1944 blaze that also gutted a third. A mother from Newton threw her three-month-old infant to the ground and then jumped out herself during the fast-moving blaze. Luckily, no one was hurt. The Mildram cottage sustained damage but was repairable.

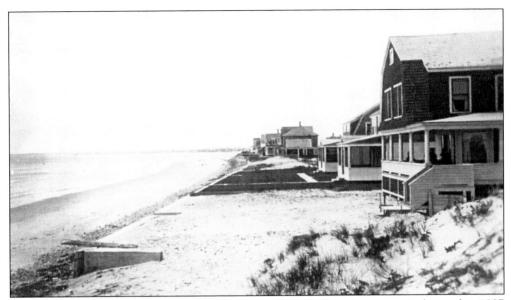

AN OCEAN SCENE AT DRAKES ISLAND. The curve of Wells Bay shows up nicely on this 1927 postcard. The Duggan cottage was the last cottage on the north end of the island at this time. Note the sand dune in the foreground.

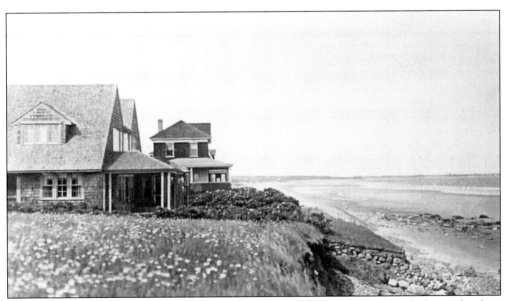

THE PARSON'S PLAYHOUSE. This cottage was built by the Parson family as a playhouse for their children. A stage was erected especially for the children to use to entertain folks. The flowered bluff in the foreground shows some erosion at the time of the picture in the 1930s. This bluff was clay and was utilized by some to make pottery.

FENWICK COTTAGE. This cottage was built in the late 1930s when the cabin style had become popular.

THE KENNEDY COTTAGE. This cottage was built in 1941 and located on the south side of Drakes Island Road and east of Eaton Avenue.

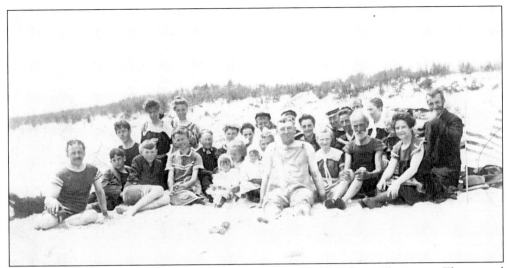

WATERFOWL AT DRAKES ISLAND. This photo was taken in July of 1904 by Lucius Thayer and labeled as such. Although the folks aren't noted individually, the following are known to be in it: the Kelleys, Mrs. Littlefield, the Bickford boys, Arthur Gillis, May and Lucy Glover (twin babies), Mr. Choates of Fitchburg, and Abbie Spooner and her father.

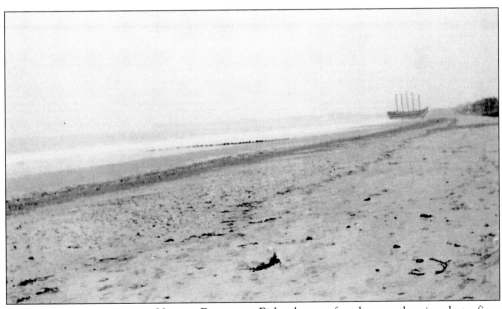

LOOKING SOUTH TOWARD THE HARBOR ENTRANCE. Either haze or fog obscures the view, but a five-masted vessel appears to be aground or just beached at the harbor entrance. Note the cork floats used as a lifeline extending into the surf.

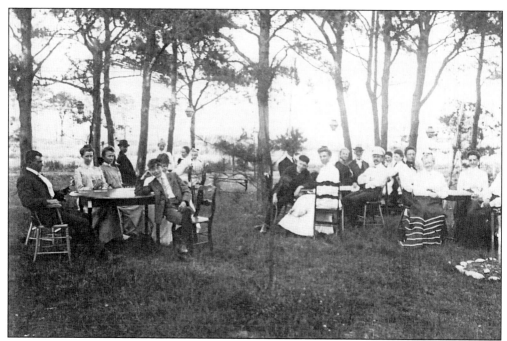

A COMMUNITY CARD PARTY UNDER THE GILLIS PINES. This 1904 picture of a gathering again doesn't list folks individually, but the Gillis, Bickford, Eaton, and Littlefield families are known to be in the picture. Note the hanging lanterns.

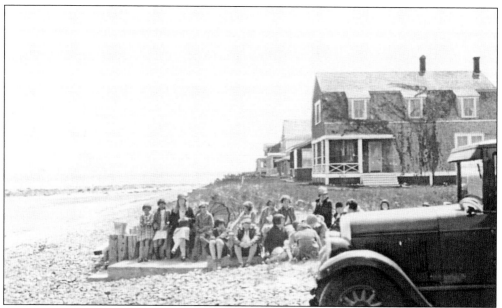

A FAVORITE SPOT. The right-of-way to the beach at the end of the Drakes Island Road was always a favorite gathering spot for the island youth. It has also been used by native motorists who are driving and hoping for a cooling breeze and view of the Atlantic.

Two

WELLS BEACH

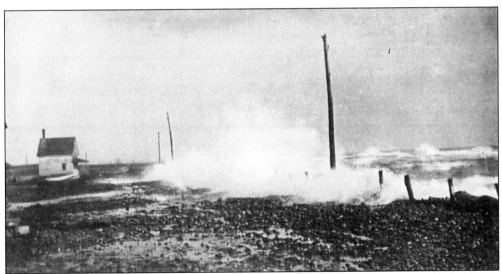

SURF AT FISHERMEN'S COVE. This early-1900s photo shows George Hatch's house with the stones and seaweed from the storm littering the way.

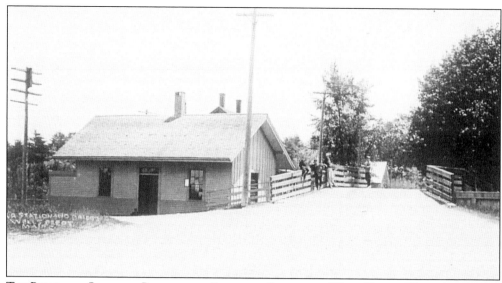

THE PORTLAND, SACO AND PORTSMOUTH RAILROAD STATION AT WELLS DEPOT. The railroad came to Wells Depot (Highpine) in 1842. Thus, it was from here that the very first guests made their 7-mile trip by buggy or stage to Wells Beach.

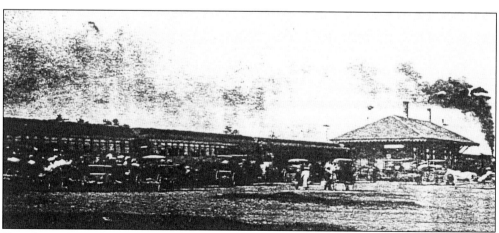

THE WELLS BEACH RAILROAD STATION. The station at this location (Depot Street) opened in 1872, when the Boston & Maine built their line. As it was closer to the beaches, the station was labeled Wells Beach. This first station burned in fires that occurred during the early 1900s.

SEA SPRAY COTTAGE. Located at the southwest corner of Eldridge Road and Webhannet Drive at Fishermen's Cove, this cottage sat beside the only road to Wells Beach before 1872. Horse-drawn buggies would bring visitors to boardinghouses from the station. This particular cottage was the year-round home of Lester and Mabel Kimball beginning in the early 1900s. The stables at the rear were converted to a store.

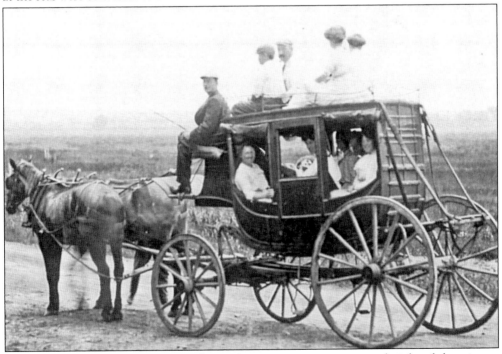

A STAGECOACH TAXI. The stage was also used to transport passengers to their beach locations.

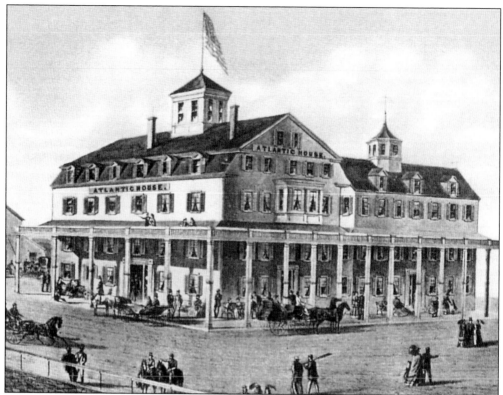

THE ATLANTIC HOUSE. The first large hotel in Wells was built in the 1840s at the Gold Ribbon Drive area of Wells Beach. John Horne, from Berwick, Maine, was the owner and proprietor. The hotel included a dining room, dance hall, billiard room, bowling alley, steam laundry, tennis courts, and livery stable. Wealthy guests would come for the whole season. The building burned on November 13, 1885.

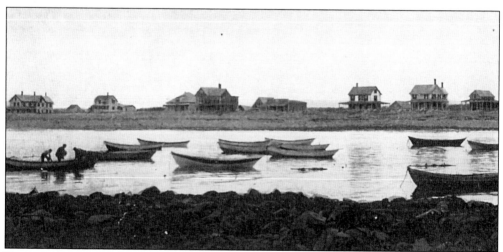

FISHERMEN'S COVE. Local fishermen moored their dories in the cove, where many residents lived nearby year-round. Reportedly, the gas lights of the adjacent Atlantic House lit up the cove sufficiently at night for rowing parties to while away the evening hours.

THE MILE ROAD. This road was known as the Island Ledge Road when it was built in 1872. It originally had been the private roadway/path of James Buffum, who utilized it to transport lumber to the wharf on the Webhannet River.

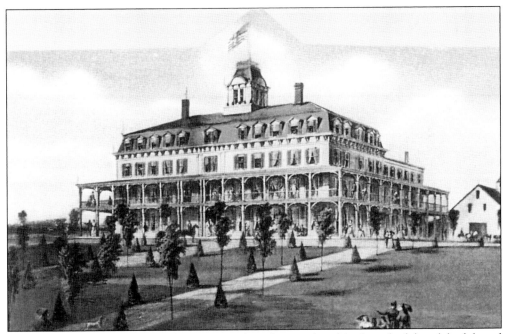

THE ISLAND LEDGE HOUSE. Built in 1872, this elegant, lavishly furnished hotel had broad piazzas all around. It was built by Harrison Davis of Somersworth, New Hampshire; Alfred Davis of Worcester, Massachusetts; and William Worster of Berwick, Maine. This complete entertainment center was considered one of the most attractive along the coast. Although it had accommodated fourteen hundred guests during one season, it was not considered very profitable when it was destroyed by fire in March of 1877.

37

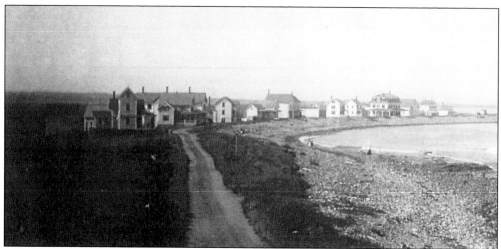

THE BAY VIEW HOUSE. The three-story mansard roof building at the north end of Fishermen's Cove was a summer hotel built *c.* 1885 by Charles Perkins. Among its guest was author Sarah Orne Jewett, from South Berwick, Maine. Her book *Deep Haven* reportedly has excerpts from her experiences when she visited here. This photo was taken prior to 1899, when the Bay View House burned on July 4. During this century, the Austin Guest cottage was moved to the location of the former hotel.

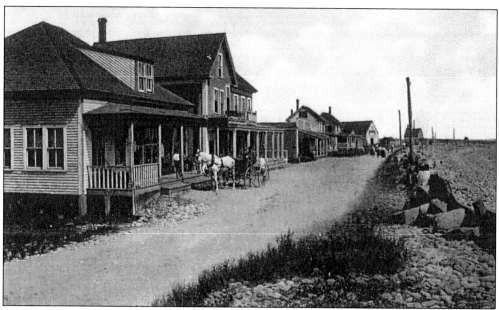

THE WEBHANNET POST OFFICE. This post office was located first at the north corner of Eldridge Road and Webhannet Drive. The postal department commissioned its first postmaster, John Davis, in 1893. This may have also been his home.

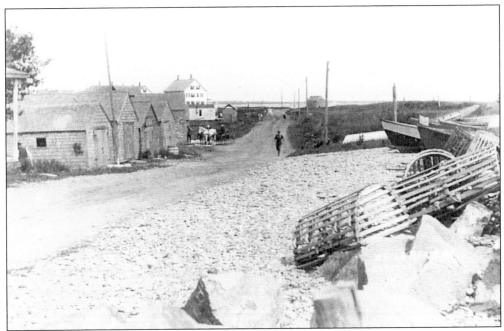

LOBSTER VILLAGE. This postcard shows the old fish houses used by the local fishermen to store their gear. Today, Lord's Lobster Pound is located at this site. The large house in the background may be the "J. Legro" noted on the 1891–92 map. In the early 1900s, the building belonged to Isaiah Chadbourne and was used as a boardinghouse.

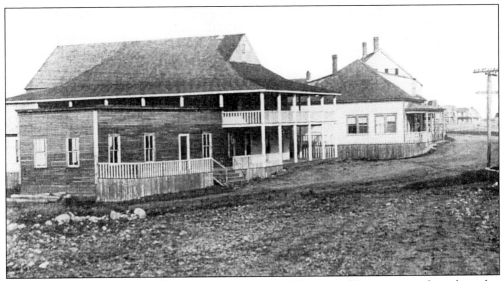

GOODWIN'S CASINO AND THE WEBHANNET POST OFFICE. The post office was moved north to this Crescent Beach location. The casino was first advertised in the *Maine Register* in 1915 as a summer amusement area that included bowling, pool tables, food, and movies.

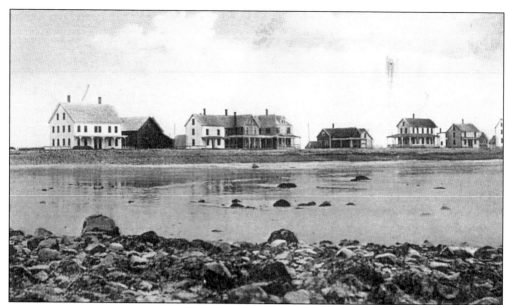

CRESCENT BEACH HOMES FROM THE ROCKS. This 1911 postcard shows Isaiah Chadbourne's Rooming House on the far left. The other beach homes, moving from left to right, belonged to the following individuals: Elmer Tobey, from North Berwick; William Batchelder, from Sanford; Mary Hall, of both Haverhill and Berwick; Jesse Horne, from Somersworth; Will Haines, from Somersworth; an unknown owner who rented the house out (it was torn down when the Marbles built there); and Dr. Hayes, from Massachusetts.

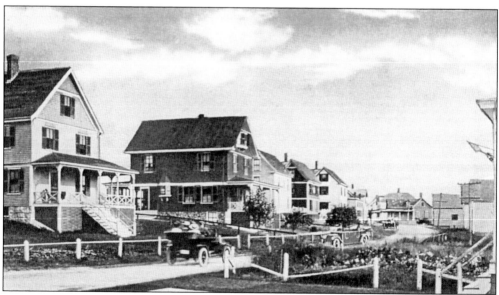

MAIN STREET LOOKING SOUTH. Known as Webhannet Drive today, this 1916 postcard shows the touring cars taking a ride along the shore. On the far left is the Batchelder cottage, now the Wellsmere; the building next to it was known as the Emery cottage.

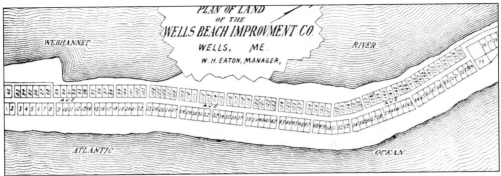

A DEVELOPER'S 1894 ATLANTIC AVENUE PLAN. R.B. Crook (president), J.B. Brackett (treasurer), W.D. Davis (secretary), and W.H. Eaton (manager) of the Wells Beach Improvement Co. stated that their "aim was to develop, and place upon the market, Cottage and Hotel sites at reasonable prices; to promote order and quiet, and whatever may be helpful to the rest and comfort of our purchasers. We offer 300 building lots in close proximity to the ocean, commanding an unobstructed view of Boon Island, Bald Head Cliffs, Kennebunk Beach, Arundel, and Cape Porpoise; also cottages for sale or rental."

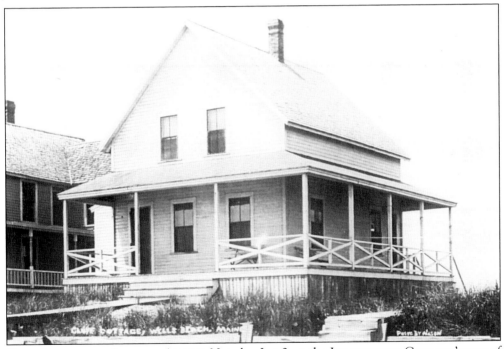

CLUFF COTTAGE ON ATLANTIC AVENUE. Noted as Lot 2 on the Improvement Company's map of sales, the cottage was given the Cluff family name. Cottages were generally known by the family name or by some title having a nautical reference.

THE IDELLA COTTAGE. This 1913 Nason photo appears to indicate that this cottage was located on the marsh side of the beach. The Idella cottage was sold by the Cluffs to the Wightmans in 1919.

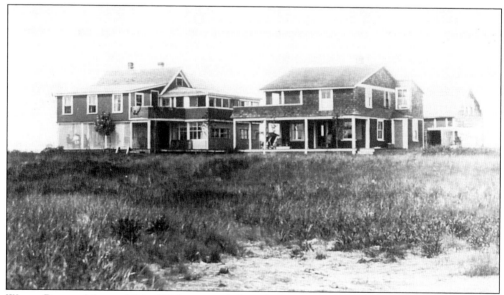

WELLS BEACH, MAINE. This 1918 postcard doesn't give an exact location but perhaps these cottages were near Ox Cart Lane. They may have been what was advertised as a tenement rental. These had communal kitchens, dining and living room areas, and individual double bedroom suites upstairs to accommodate families.

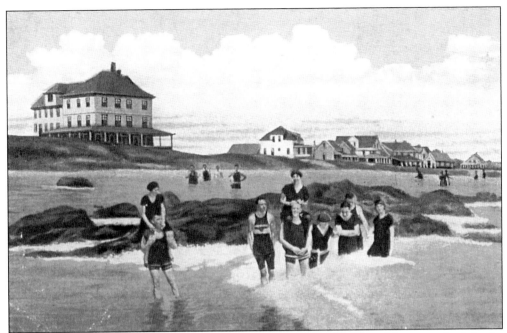

A Scene at Wells Beach. This 1917 postcard shows the Ocean View House on the left, the white Bon-Aire cottage, and the larger white building, the Atlantic House, at the right.

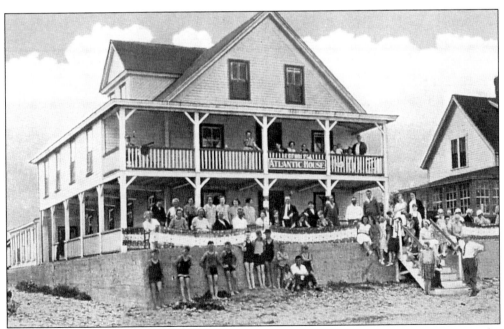

The Atlantic House. The Atlantic House was first advertised in the *Maine Register* in the 1915–16 issue, and Fred Vashon was noted as the proprietor. Alfred Rousseau replaced him in later years.

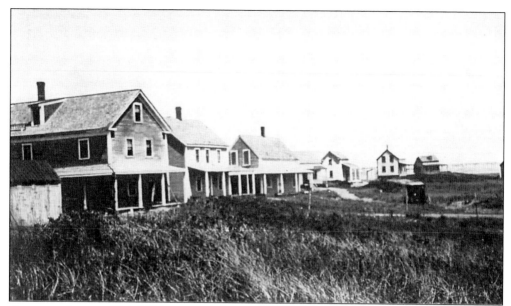

ATLANTIC AVENUE. This 1912 postcard shows a touring car on the narrow road, located mid-right in the picture, known as Atlantic Avenue.

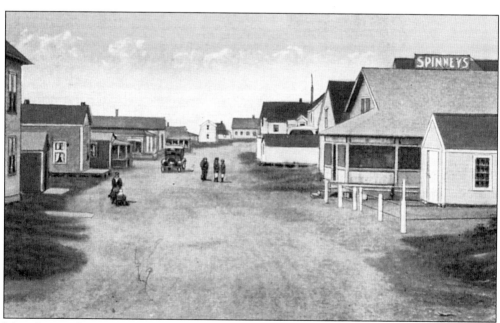

MAIN STREET, WELLS BEACH. This 1921 postcard confirms that Atlantic Avenue was also called Main Street at that time. Spinney's Restaurant was on the street side of the Atlantic House.

PADDLING IN THE WATER AT FLOOD TIDE. In the late 1930s Jean (Hayes) Gray stands for her picture in front of the Sagamore and Mohawk Cottages on Fifth Avenue.

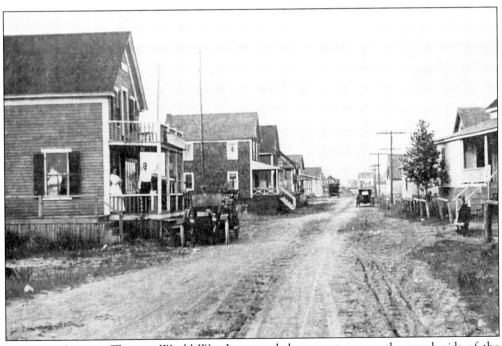

ATLANTIC AVENUE. This pre-World War I postcard shows cottages on the marsh side of the avenue, possibly just south of Johnson Avenue. Nob Hill can be seen in the background.

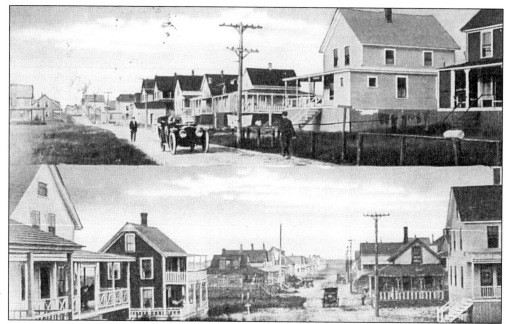

LOOKING NORTH ON ATLANTIC AVENUE. This 1917 postcard's upper view shows the beach side, while the lower view is of the Nob Hill, Sagamore Avenue area. At the end of the street can be seen the dunes.

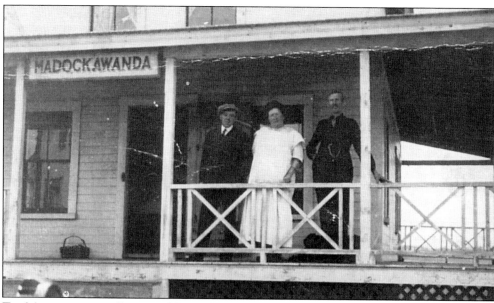

THE MADACKAWANDA COTTAGE. Native American names were used frequently as cottage names in the early 1900s. This cottage was built in 1909 by Albert Perkins, from North Berwick. Standing on the porch, from left to right, are Albert's brother, Dolphin Perkins; his wife, Katie Belle (Boston) Perkins; and Albert Perkins. This is possibly the East Wind Cottage today.

THE IVERNIA COTTAGE. Directly behind Elinor and Carolyn Hayes is the Ivernia Cottage, named for the lead ship in a popular shipping line. The cottage was built in 1909 by Lester Boston, a Boston & Maine Railroad man from Massachusetts, and is still being enjoyed by generations of his family. Lester's father, a local farmer, was amazed that anyone would pay $200 for a houselot on sand dunes!

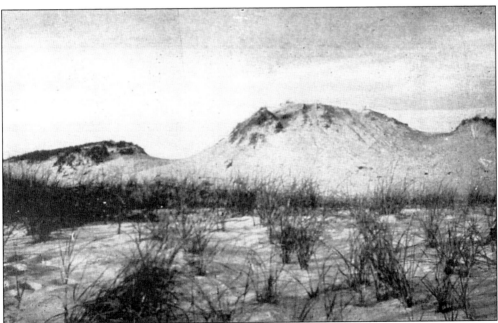

SAND DUNES, WELLS BEACH. The hillocks and hummocks of the sand dunes were leveled and comprised the foundation on which the summer colony of cottages was built. In this 1935 postcard, high dunes still existed at both ends of the beach.

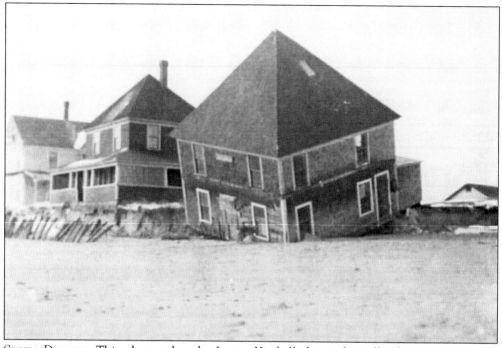

STORM DAMAGE. This photo taken by Lester Kimball shows the toll taken upon cottages bordering the mighty Atlantic. This may have been the Simonds cottage following the 1933 storm.

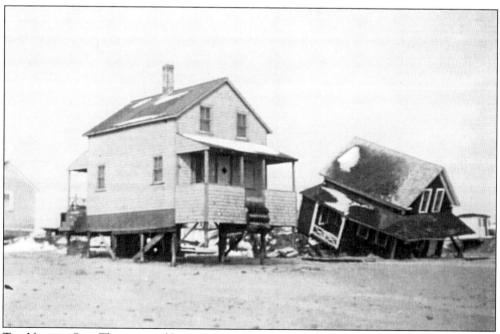

THE VIOLENT SEA. The storm of January 31, 1933, was recorded by historian Annie Bates as a severe one that toppled many cottages at the northern end of Atlantic Avenue.

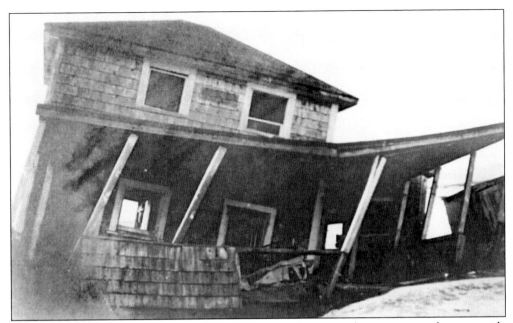

THE COTTAGE WELLS VIEW AFTER THE STORM. This was the next to last cottage on the ocean side of Atlantic Avenue prior to the 1933 storm. The owners were a family by the name of Wells from North Berwick.

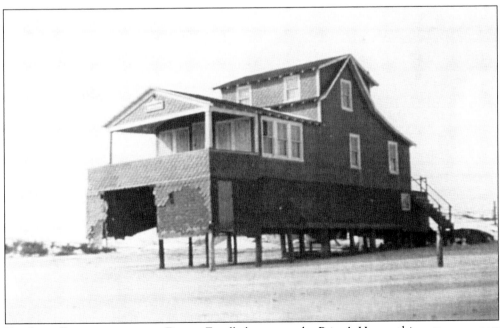

THE LAST COTTAGE BEFORE THE DUNES. Fondly known as the Priest's House, this cottage appears to be the lesser damaged of the two. Today it is situated opposite Riverside Drive.

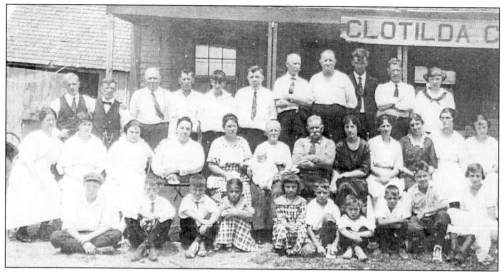

A WORMWOOD FAMILY REUNION AT CLOTILDA COTTAGE. They are, from left to right: (front row) Carl W., Albert Whitney, Ray Chase, Marion (Chase) Oliver, Emelie (Chase) Chick, Buster W., Merle Chase, Ross W., Gordon W., and Eva W.; (middle row) Blanche W., Edith (W.) Butland (Sayward, Welch), Edither Cole, Coral (Goodwin) W., Edith (Guptill) W., Francetta W. (holding Kenneth Butland), Samuel W., ? W., Jessie W., Zoe (Day) W., Louie W., and Alice Whitney; (back row) Guy Cole, Albert Whitney, Archie W., Ernest W., Newell W., Percy W., Perley W., Harry W., the chauffeur, Ross W., and Louise W. Clotilda Cottage was located on Ox Cart Lane.

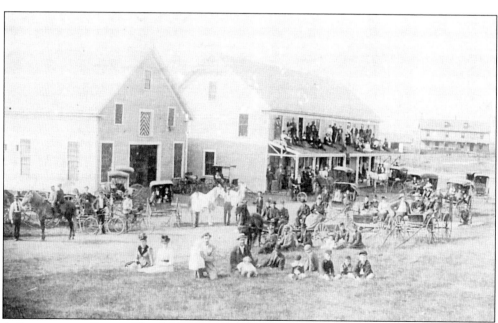

A PICNIC AT THE BEACH. The Odd Fellows held a picnic at the site of the old Gilman Stables noted on the 1891–92 Cadastral map. Note the Studley Hotel in the background.

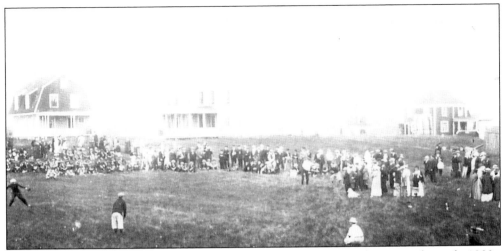

BASEBALL AT THE BEACH. The national pastime brought out a crowd even in the early 1900s. This Worcester team, who camped at Moody Point, reportedly played a team from the inland cities of Maine.

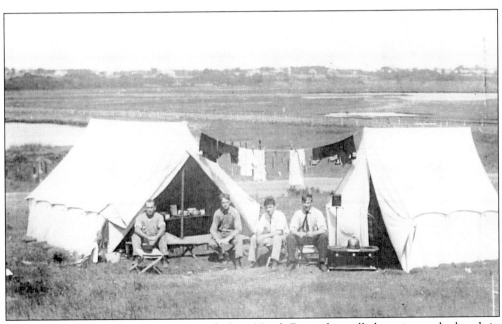

TENTING AT THE BEACH. Thomas Kennedy from North Berwick recalled tenting at the beach in his younger days with a group of his friends. They dug their own clams, then cooked them for their meal. The identity of these folks is unknown. Note the camp stove in front of the tent at the right and the bathing suits on the line. The Mile Road is in the background.

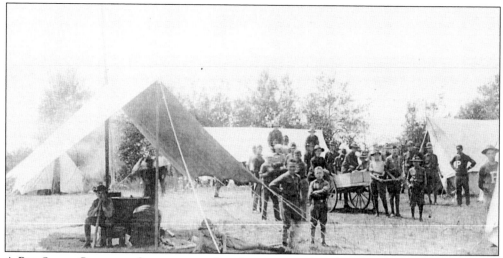

A Boy Scout Camporee. Scouts, too, enjoyed camping and working on their badges in the salt air of the beach area.

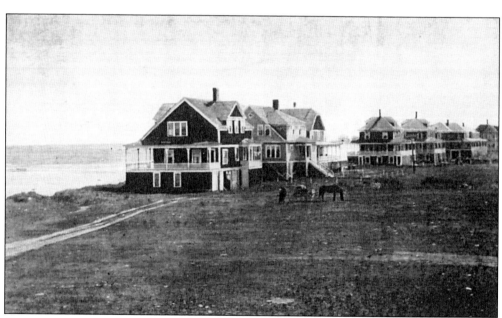

Cottages along the Shore Front. Most of these cottages, located just south of the main beach, were built at the turn of the century by Sanford mill owners and/or agents. From left to right, the cottages are: Littlefield's Dorothea, Bennett, Symonds, Nutter, Thompson, and the Barnacle. The Dorothea has been moved to Webhannet Drive, but the rest are still recognizable today at this location.

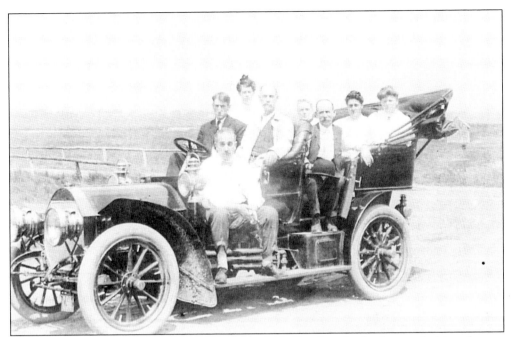

A TOURING CAR AT NASON'S STUDIO. With the Mile Road in the background, this unknown group wanted a permanent photo souvenir of their trip to the beach. The license plates tells us that this is an out-of-state vehicle.

THE BELLEVUE HOTEL. Frank Sevigney owned and operated this hotel at Casino Square. The hotel not only accommodated guests, but also provided gas for their cars (note the gas pump at the lower right).

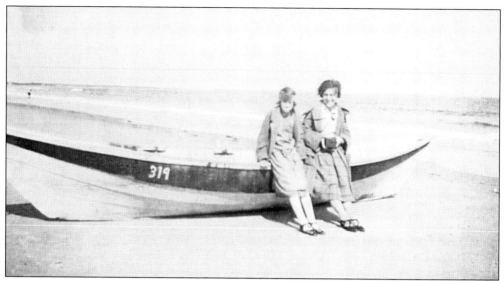

THE RESCUE DORY AT THE MAIN BEACH. This photo was taken prior to 1920. Leroy Nason's daughter Gladys poses on the right with her friend, using the dory as a backdrop.

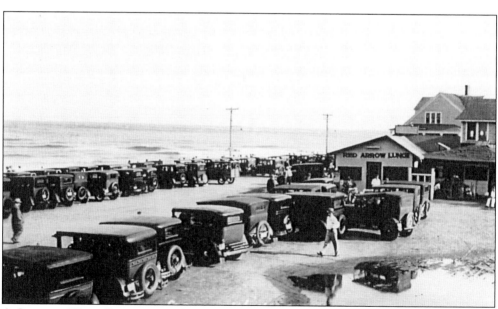

A SCENE AT WELLS BEACH. Note the double row of vehicles parked along the shore front in this 1930s postcard. The Red Arrow Lunch was located to the north of Forbes' Restaurant at this time.

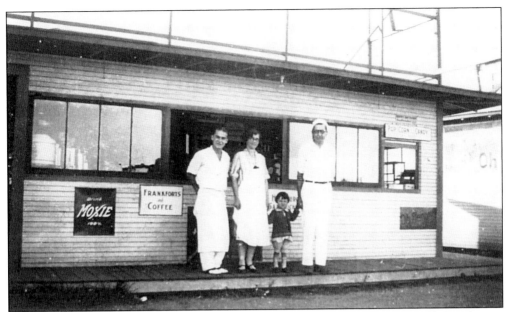

FORBES' RESTAURANT. Vander Forbes Sr. began his first food enterprise at Wells Beach in a 9-by-12-foot building with three stools in 1924. In this 1926 photo, the building had expanded to be 20 by 20 feet and had increased to twenty-four stools. Shown here, from left to right, are Wilfred Sevigney, Marguerite Forbes, Ruth Forbes, and Vander Forbes Sr.

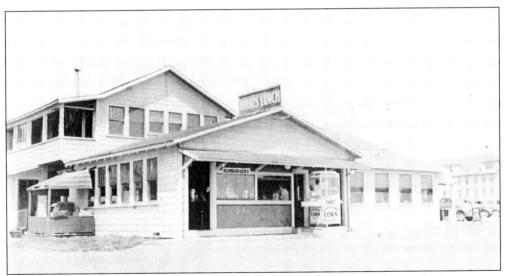

FORBES' LUNCH. The establishment continued to grow over the years. Today the third generation of the Forbes family continues the tradition established by their grandfather.

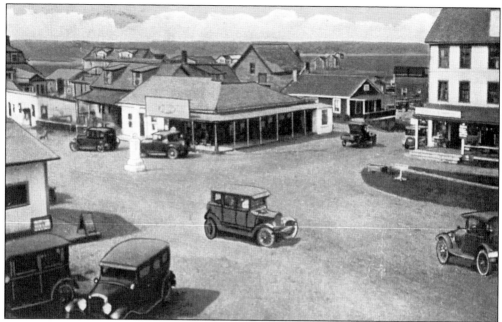

CASINO SQUARE AT WELLS BEACH. This late-1920s postcard states that "this is a good place to enjoy the shore."

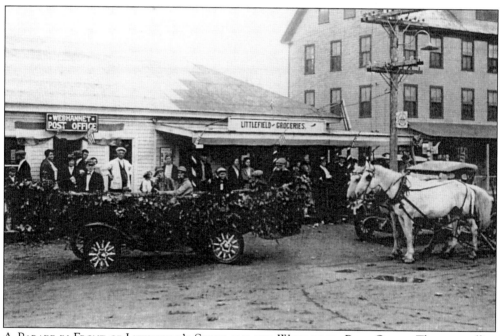

A PARADE IN FRONT OF LITTLEFIELD'S STORE AND THE WEBHANNET POST OFFICE. The post office was moved to this location in the 1920s. Harry Littlefield (seen in the white jacket) surveys the decorated boat of Wesley Moody. The local firemen sponsored a carnival to raise funds for the first firetruck.

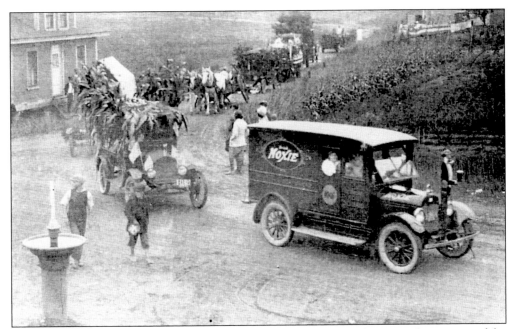

A Parade at the Intersection of Ox Cart Lane and Mile Road. This is another section of the Firemen's Carnival parade. The wagon with the broken wheel belonged to Willis Batchelder.

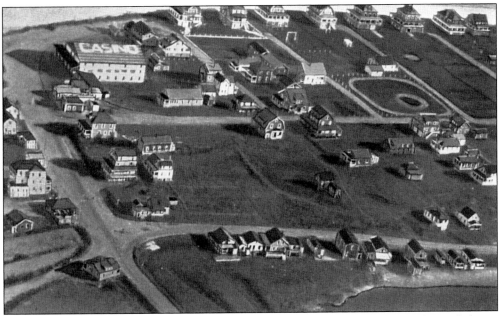

Wells Beach and the Casino from the Air. Photographer Socrates Topalian took aerial photos in the early 1930s. Note the horse track at the upper right. Charles Poulson ran the track in the field bordering Gilman Avenue and Church Street. His house was at the southwest corner of Island Ledge and Church Streets. The current Blue Spruce cottage was the stable for the track's horses. The lettering on the roof of the Casino was to assist pilots of that day to determine their location.

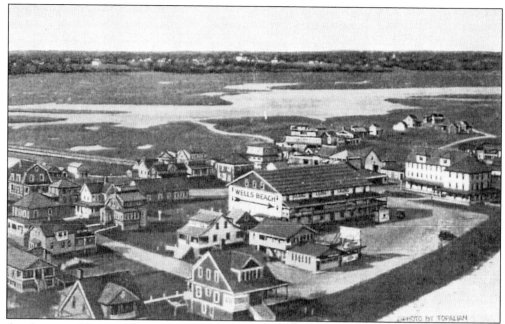

AN AIRPLANE VIEW OF WELLS BEACH, THE CASINO, AND THE WEBHANNET RIVER. This postcard shows the *Dorothea*, Forbes' Lunch, the Casino, and the Marguerite Hotel (in the foreground).

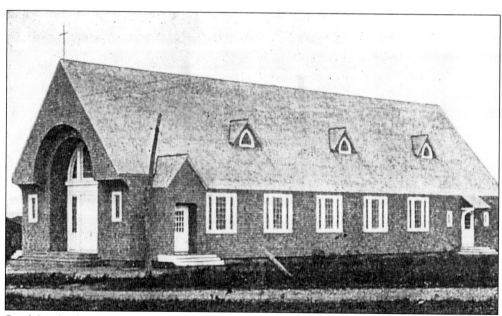

ST. MARY'S CATHOLIC CHURCH ON CHURCH STREET. This church was built in 1920 to accommodate the summer visitors. Winterized in 1957, it served its members until the present church was built on Eldridge Road. This building is now called the Haven and provides lodging for summer visitors.

MAIN STREET LOOKING EAST. This c. 1916 postcard shows what is now Webhannet Drive. The Island Ledge Casino appears to be at the end of the street on the right.

COTTAGES ON WEBHANNET DRIVE. This 1911 postcard has an arrow with the caption: "Highwater in the center of the photo." However, whether the reference is to an actual high water mark at flood tide or the name of a cottage is uncertain.

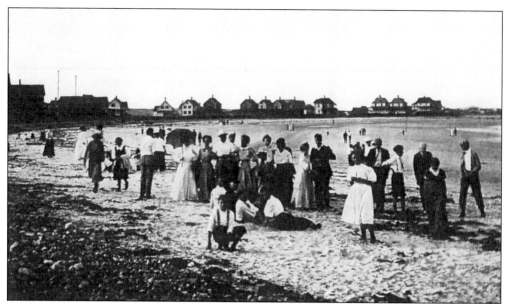

A CRESCENT BEACH GATHERING. Perhaps this 1911 gathering occurred on June 26, known as Cure-All Day locally. Folklore records that any person bathing in the ocean on that date would be healed of disease or receive strength. At the turn of the century, records note that many came, bands played, and schools recessed—it was "party-day" at the beach.

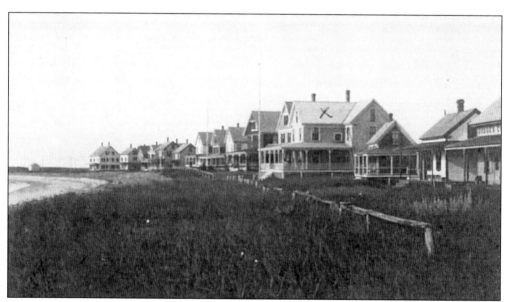

LOOKING TOWARD CRESCENT BEACH. This 1907 postcard shows the hunter's cabin at the far left. On the right, the cottage name appears to be "Judge." The dune grass provided a carpet of green, and a wooden rail fence denotes the seawall.

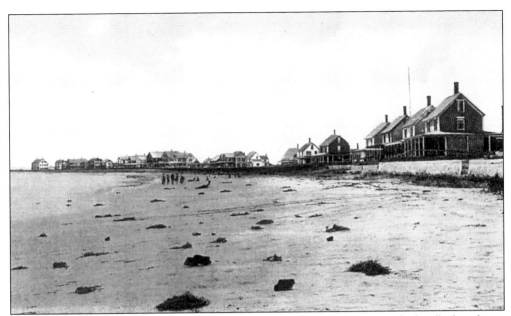

STROLLING ALONG THE BEACH. Folks enjoying a stroll in the early 1900s undoubtedly found it as soothing as we do today. It is recalled that farmers brought their haying crews to the beach after a day of work. They felt strongly that a swim in the salt water would serve as a preventative against poison ivy encountered while haying.

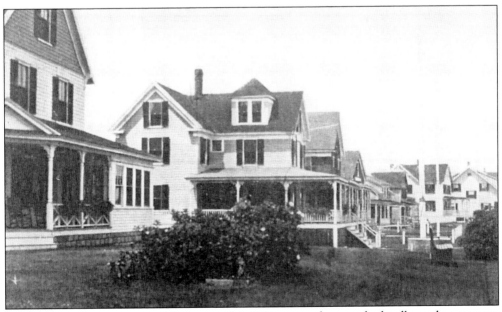

THE ROBERTA COTTAGE AT THE CRESCENT. This 1931 postcard was undoubtedly used to promote a seasonal rental.

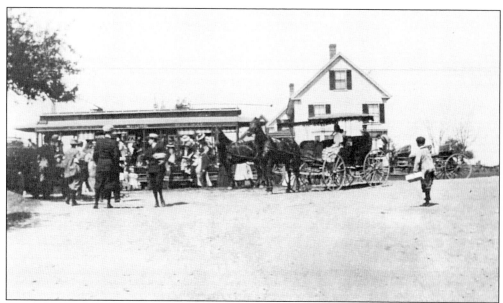

AN ELECTRIC CAR STOP AT THE MILE AND POST ROAD INTERSECTION. The Atlantic Shore Line served Wells Beaches from 1907 to 1923. Summer visitors disembarked to a horse-drawn buggy for the trip to the beach. Herbert C. Littlefield's house is in the background. He provided transportation with depot carriages and buckboard parties. His advertisement noted that he had cottages to let and that he was also a dealer in "Hay, Wood, Ice, Milk and Vegetables."

THE MILE ROAD FROM THE POST ROAD INTERSECTION. This 1914 photo shows the wharf midway on the river where the schooners docked. This is the location of Billy's Chowder House today. The bridge over the Webhannet River and the road to the beach was built by the Town in 1872.

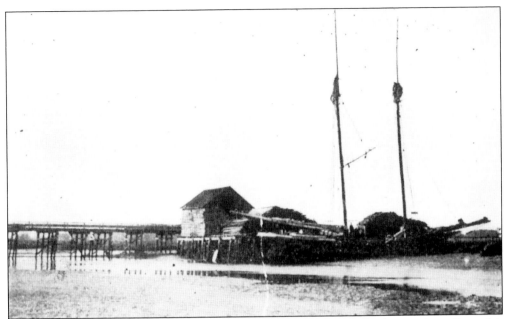

THE *ALICE S. WENTWORTH AT ANCHOR*. As visitors came to the beach, they might well see this schooner. This was the last coastal schooner to come regularly into Wells until the 1920s. Its outgoing cargo was lumber, as seen piled here. Its incoming cargo was coal, which was stored in the shed at the wharf.

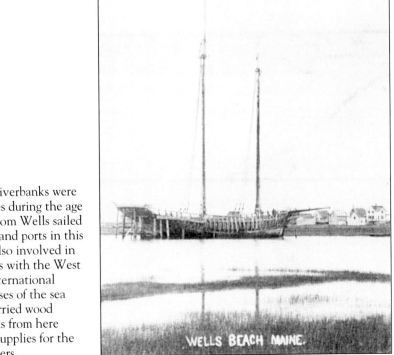

SHIPBUILDING. The riverbanks were used as building sites during the age of sail. Schooners from Wells sailed not only to Boston and ports in this country, but were also involved in the triangular trades with the West Indies and other international ports. The workhorses of the sea lanes, schooners carried wood and lumber products from here and returned with supplies for the merchant-ship owners.

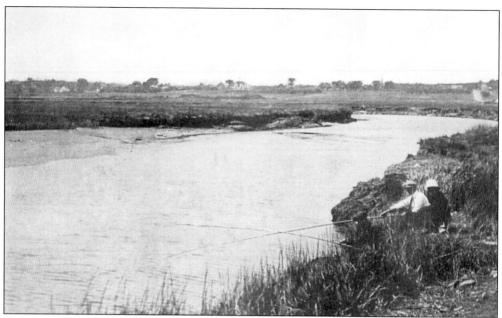

FISHING ON THE WEBHANNET RIVER. For those not wishing to fish from the open dories on Wells Bay, the catch at high tide along the Webhannet River was often sufficient.

THE DYKE ON THE WEBHANNET RIVER. The dyke, or dike, was built in the late 1800s to control the tidal waters on the marsh, thus facilitating the haying. All owners of the marshlands were billed by the Town for the building of the dyke in 1892. Thereafter, annual bills were submitted for the maintenance of the dyke. Remnants of the dyke can still be seen from Mile Road and Webhannet Drive.

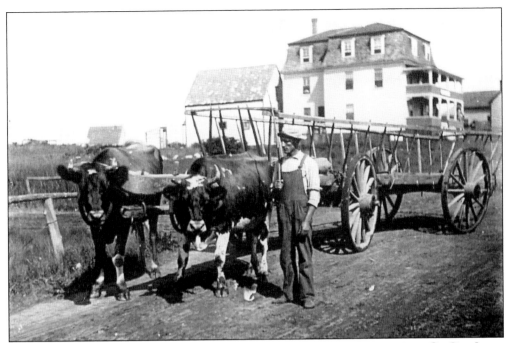

A Team of Oxen with a Hay Wagon. In this photo, Pete Sevigney pauses near Ox Cart Lane. Undoubtedly, the team would soon be hauling a load of marsh hay.

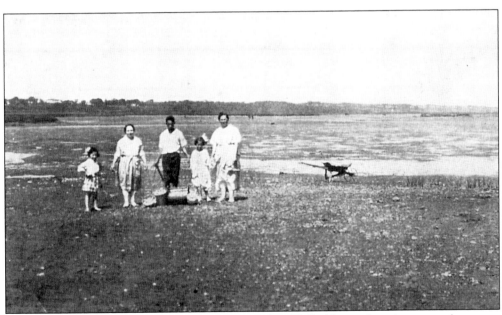

Dredging Clams. Clams have always been enjoyed in Wells. Native Americans were known to have harvested them, leaving piles of shells behind. Certainly they must have provided a readily available food source for the earliest settlers. Summer visitors also enjoyed digging them. Here a family pauses while harvesting.

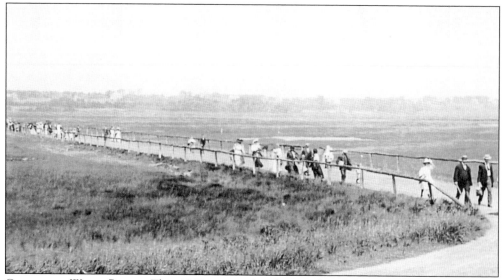

COMING TO WELLS BEACH. This 1912 postcard indicates that folks did not always wait for transportation to the beach. At this time, the Mile Road was barely wide enough for two buckboards to pass!

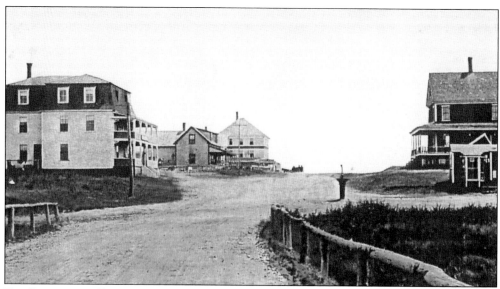

THE SCENE AT THE END OF MILE ROAD. The Bellevue Hotel is located at the left with Littlefield's Store and Ocean View House in the distance. On the right is Nason's Photography Studio and the Stacy home behind it. Note the water fountain at the intersection. This was placed there in 1901 for use by man and beast.

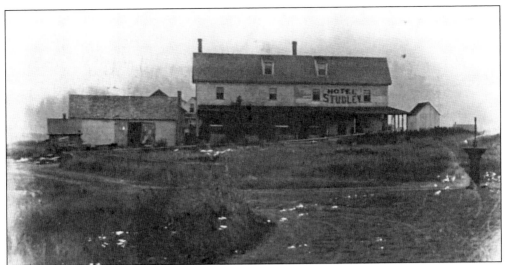

THE STUDLEY HOTEL. A family by the name of Studley operated this hotel on Ox Cart Lane. It would later be called the Woodbine Cottage by the same family.

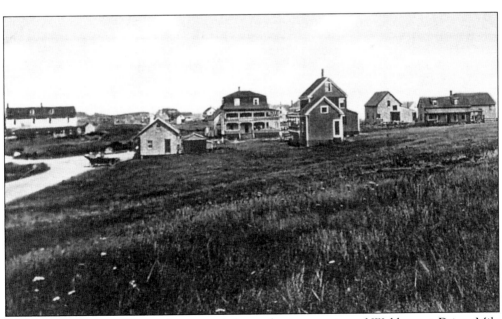

LITTLEFIELD'S CORNER. This early postcard shows the intersection of Webhannet Drive, Mile Road, and Ox Cart Lane. From left to right are the Studley Hotel, Nason's Studio, the Bellevue, Stacy House, and Littlefield's corner.

LEROY NASON (1875–1955). Leroy Nason was a photographer who lived at the house on the left during the summer months. His photographs from the mid-1890s to the 1950s provide a wonderful pictorial history of the beach area.

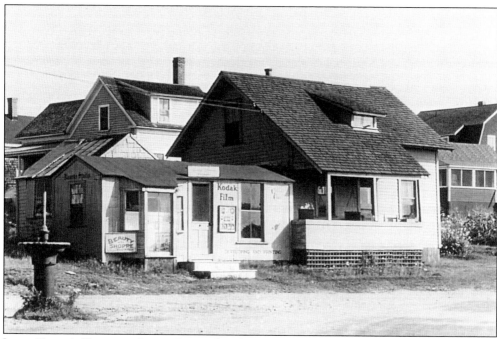

LEROY NASON'S HOME AND STUDIO. Located at the corner of Webhannet Drive, this place could be the first stop for folks wanting their trip to the beach recorded. The Beauty Shoppe was maintained by his wife. He also developed films. Again, note the close-up of the water fountain.

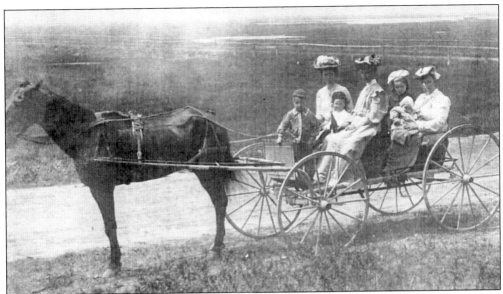

A FAMILY DAY AT THE SHORE. This 1907 photo captures a family from in-land Wells pausing for their picture. They are as follows: (front seat) Mabel (Goodwin) Day, driving the horse; her children, Harland and Gladys (Day) Colby; and in the foreground, Julia Lawson, a neighbor and owner of the horse and wagon; (back seat) Coral (Goodwin) Wormwood, holding daughter Louise (Wormwood) Damron; and to her left, daughter Edith (Wormwood) Welch. Mabel and Coral were sisters.

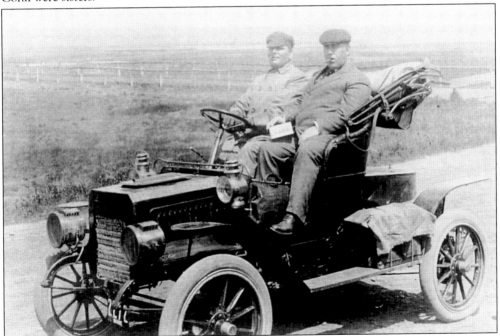

AN EARLY TOUR BY CAR. Nason's collections show an early car and unknown gentlemen pausing for this photo. The Maine license plates tells us this was in 1907. The car resembles a steam car built in Auburn at this time by Edwin F. Field. Note the guard rails of the Mile Road in the background.

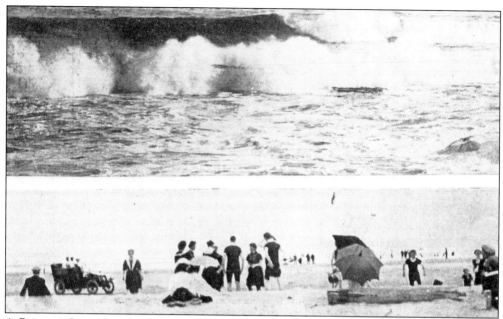

A BATHING SCENE AND SURF. In 1907 cars drove on the beach and dark-colored bathing suits and umbrellas were fashionable.

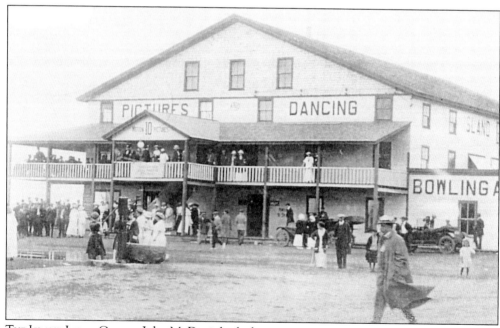

THE ISLAND LEDGE CASINO. John M. Davis built this entertainment center c. 1909 and advertised it as the largest and best on the Maine coast. Included at the entertainment center were six bowling alleys, four pool tables, moving pictures, an ice cream parlor, and a lunch and dining room. He also claimed its dance floor was one of the best in the area.

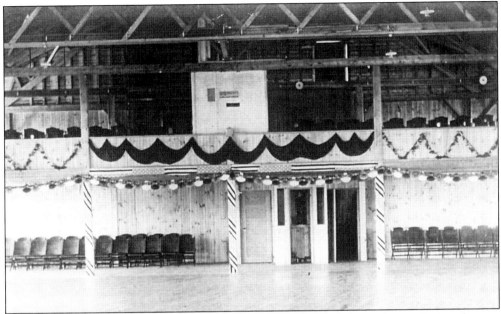

THE BALLROOM AT THE CASINO. An upstairs dance floor with balcony featured open shutters overlooking the square and the beach. A glistening reflective globe revolved from the center, while a five-piece dance band played from the stage at the end. At one time the Broggi & Firth Band from Sanford played for the season.

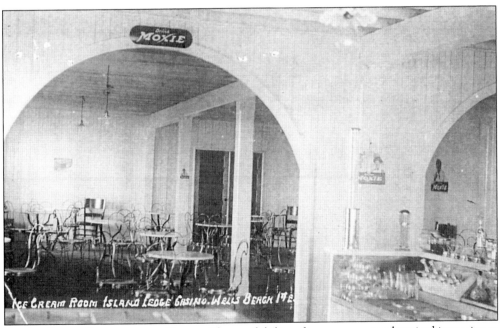

THE ICE CREAM PARLOR AT THE CASINO. The availability of ice cream was advertised just prior to World War I. Moxie ads appear to promote this as the beverage of choice in this postcard.

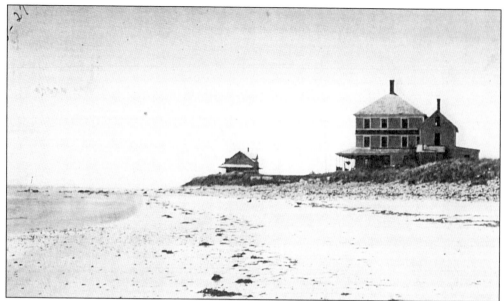

THE WENONA. This 1905 postcard shows the Wenona Hotel, owned by C.E. Stacy, on the right. The cottage in the center may be the Dorothea, a rental owned by the Littlefield family.

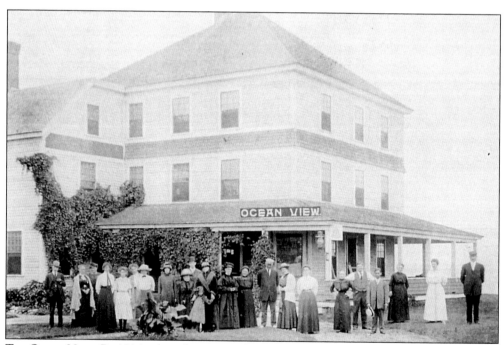

THE OCEAN VIEW. By 1914, when this postcard was made, the Wenona had become the Ocean View. Over the years it has been known as the Marguerite and the Driftwinds; it is now part of the Lafayette Oceanfront Resort. In 1916 the Ocean View was advertised as the "most complete American Plan Hotel on the Maine Coast."

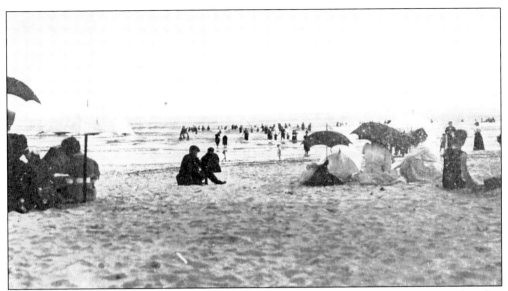

A Bathing Scene. This 1912 postcard depicts a small section of the miles of Wells Beaches that have beckoned visitors for a century and half.

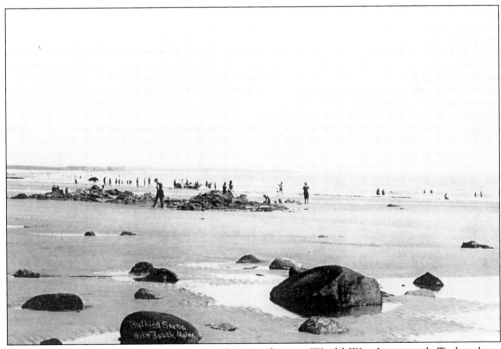

Tidal Pools. The tidal pools were prevalent in this pre–World War I postcard. Today these pools entertain families with young children even as they did eight decades ago.

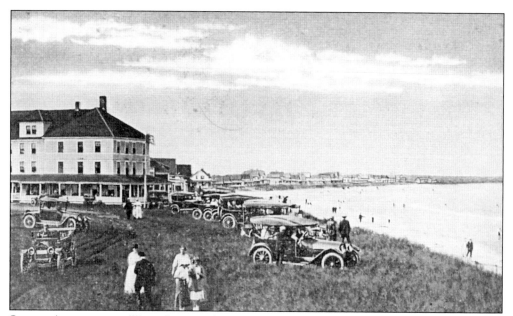

Sunday Afternoon at Wells Beach. This 1916 postcard shows the sea grass parking lot divided by a sandy walking path. By this time the hotel in the background was owned by G.G. Runnels and was called the Ocean View.

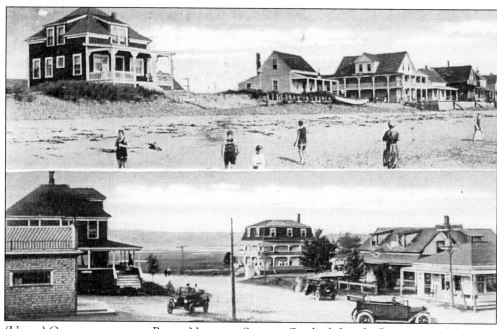

(Upper) Cottages from the Beach North of Square. On the left is the Bon Aire and the large building on the right is the Atlantic House.
(Lower) The Square from the Casino. The edge of the building on the left is the movie theater; it is followed by the Stacy House, Bellevue, and the Littlefield home and store.

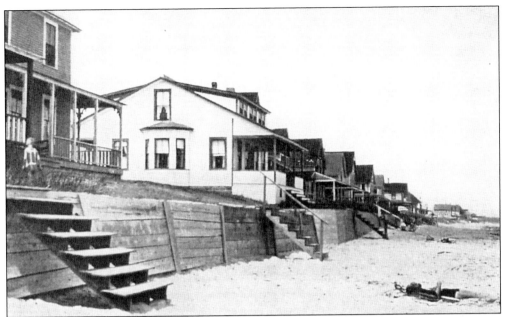

THE BEACH LOOKING NORTH. Note the height of the wooden seawalls with the steps descending to the beach in this 1920s postcard.

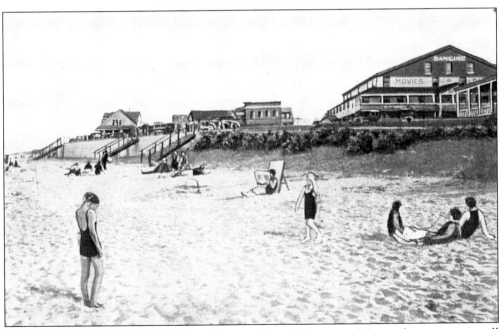

THE BATHING BEACH AND ISLAND LEDGE CASINO. This 1931 postcard shows the cement seawall at the main beach. Beginning in the 1920s, the Town added sections of cement walls each year along the shore until the whole beach had been done. The message on this card says, "Arrived O.K.—a beautiful place—having a fine time."

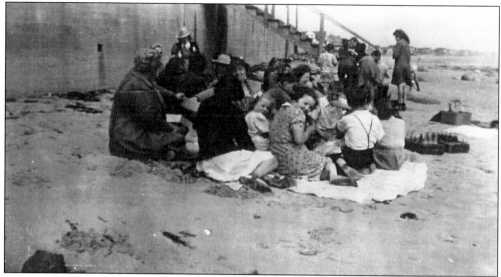

A SCHOOL PICNIC. It was almost a tradition that the rural one-room schools of Wells would picnic at the beach at the end of the school year. Here, the group from the Division 9 Pine Hill School enjoys their visit on June 5, 1942. Bertha Bourne was the teacher who planned the trip.

THE DIVISION 3 ELDRIDGE SCHOOL PICNIC. This school outing occurred in May or June of 1943. Lydia Kimball is the girl smiling at the camera. In many instances this was the only time all summer that local children enjoyed a visit to the beach.

A KIDDIE ON THE BEACH. A lifeboat stands ready in the background even in the 1930s when these families were enjoying "fun in the sun."

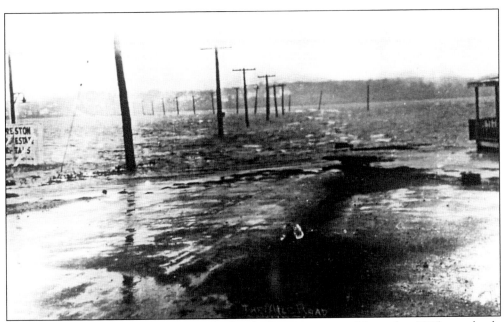

THE FLOOD TIDE OF 1945. An extremely high tide during a storm in November 1945 completely obliterated the Mile Road. Subsequent upgrading of the road has helped to nearly eliminate storm damage in recent years.

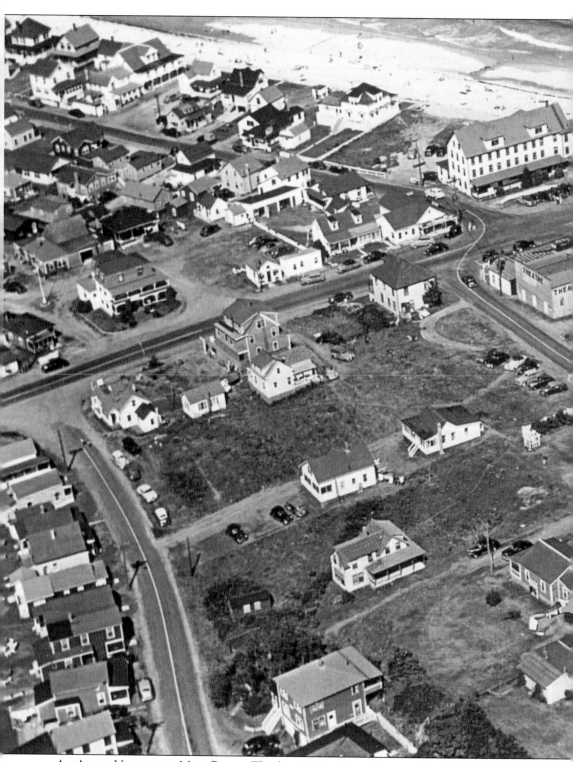

AN AERIAL VIEW OF THE MAIN BEACH. This late-1940s photo shows open spaces, as the building boom following World War II was only just beginning. Gradually the theatre and bowling alley

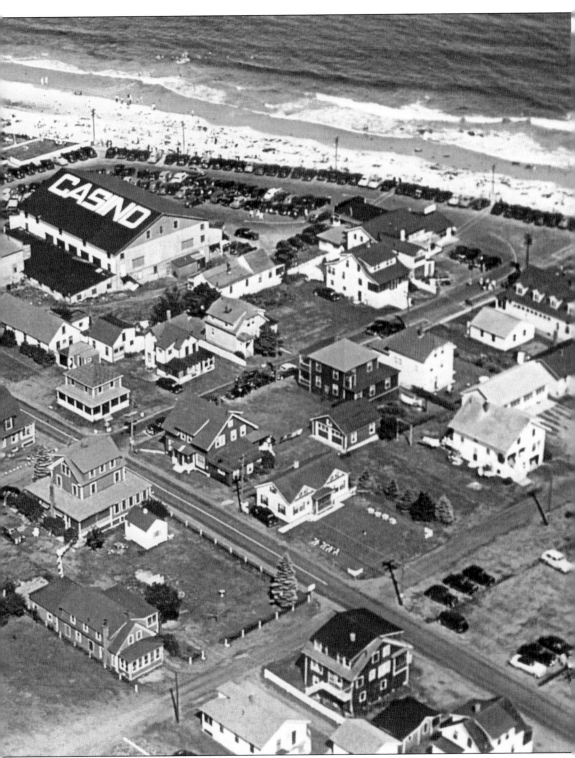

disappeared, and finally the Casino itself was torn down on October 2, 1986.

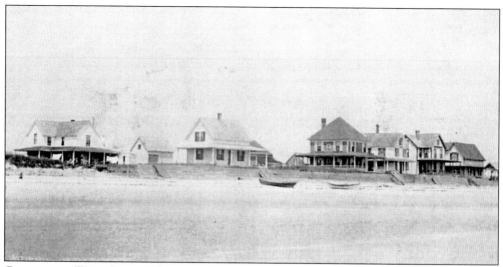

COTTAGES AT WELLS BEACH. This postcard doesn't give its exact location but it is possibly a view at the end of Folsom Street. One grandfather remembers a stag party taking place at the third cottage from the right. In this era, the four corners of the tablecloth were gathered together when the meal had ended, and the whole lot was thrown in the ocean!

MOTHERS AND DAUGHTERS AT THE BEACH. Mary and Katherine Wentworth (left) and Grace and Mary Hall enjoy the warm beach sand at Crescent Beach c. 1914.

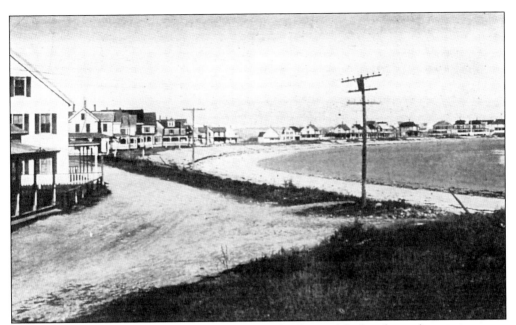

THE CRESCENT, WELLS BEACH. This postcard shows the shape of the beach, resulting in its name. The large house on the left was owned by the Chadbourne family initially but it was later owned by the Hooz family from Sanford.

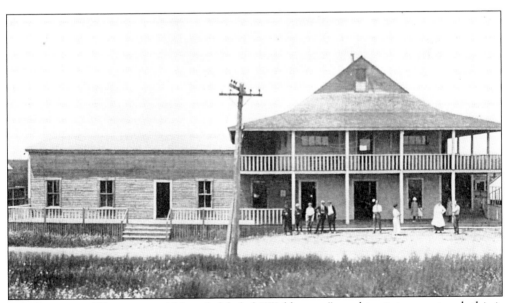

THE CASINO AT WEBHANNET. Although labeled "Webhannet" on this vintage postcard, this is the Crescent Beach area of today. Bowling alleys, movies, and dancing catered to the guests at this area of the beach. This Casino burned in the early 1930s.

CRESCENT BEACH, THE WEBHANNET CASINO, AND THE POST OFFICE. The Casino is on the left with the post office next to it in this postcard. The cottage on the right was built by a Sanford mill owner by the name of Lowe. He rented the cottage for the whole season.

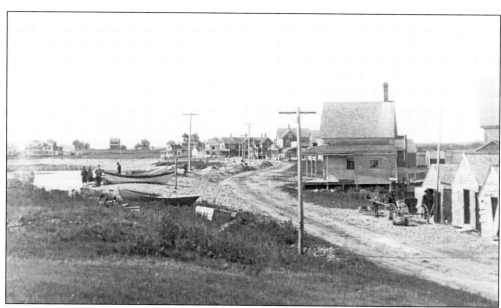

WEBHANNET DRIVE, FISHERMAN'S COVE. In this c. 1910 photo, Webhannet Drive was no more than a narrow carriage path. Electricity was provided initially only from June 15 to October. The George Hatch house is just beyond the fish houses.

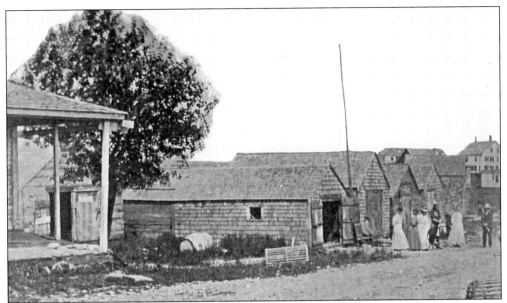

OLD FISH HOUSES. Located originally at the site of Lord's Lobster Pound of today, these buildings were used by the local fishermen for storing their gear.

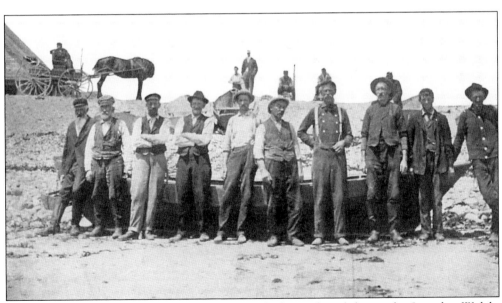

WELLS BEACH FISHERMEN. This c. 1900 photograph shows, from left to right, Langdon Welch, Christopher Eaton, George W. Moody, Will Stevens, Edward Watson, Leander Perkins, Alvin York, Sylvester Gray, Fred Studley, and James Flaker.

THE WELLS BEACH FIREHOUSE. THE Wells Beach Hose Company was formed in 1910. In 1913 George W. Moody built this building for them to store their hose and reels and to provide a meeting hall for the volunteer firemen. The bell tower was added in 1923.

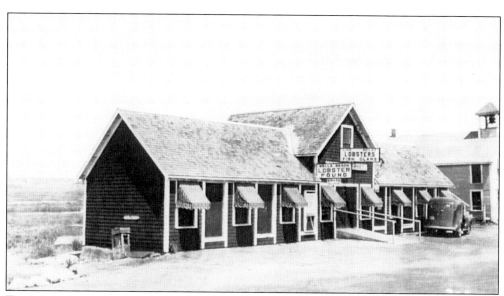

THE WELLS BEACH LOBSTER POUND. This structure was built prior to the firehouse (probably c. 1912) by the Hatch family to replace the fish houses of the earlier decades. The Hatch family both wholesaled and retailed fish and lobsters from this site.

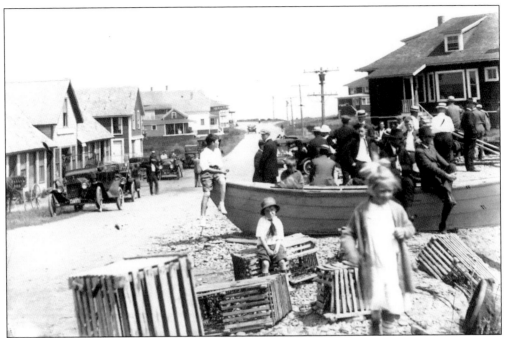

A Summer Scene at Fishermen's Cove. This *c.* 1916 photo shows the Lobster Pound as a gathering place. Note that both a horse-drawn wagon and Model Ts were in use at this time.

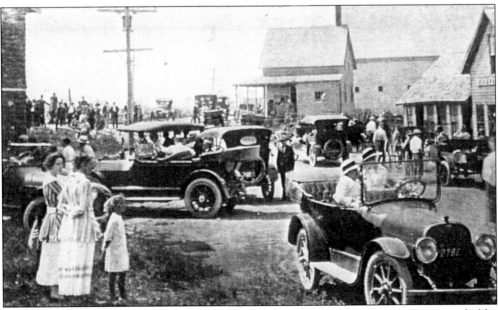

The Firemen's Carnival. In the summer of 1920–21, the Wells Beach Hose Company held a carnival to raise funds for a firetruck. Folks gather here to await the parade shown earlier at Casino Square. Boat races, hose contests, and other activities also took place on that day.

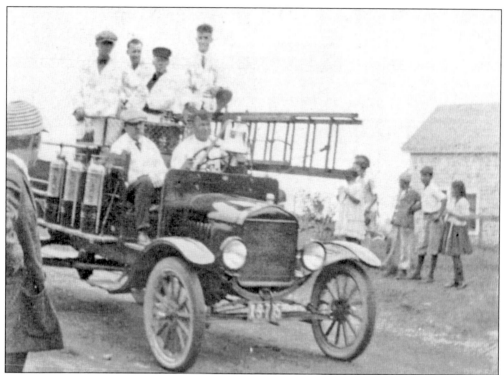

THE FIRST WELLS BEACH FIRETRUCK. This Hose No. 1 1921–22 Model T hose-wagon truck was purchased by the Hose Company for $750 from Grover Perkins' Ford Garage in Ogunquit in 1922. Austin Guest is the driver here. Elmer Welch is the passenger.

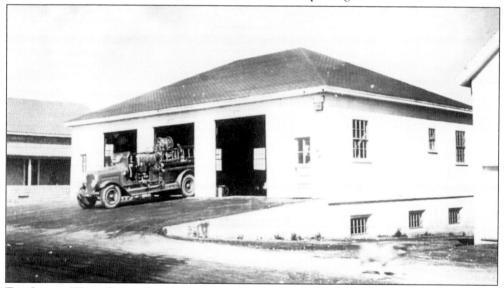

THE SECOND WELLS BEACH FIRE STATION AND TRUCK. The second station was begun in 1942 by volunteer firemen George W. Moody, Donald Moody, Weldon Morrison, Perley Jellison, and others. The second truck, a 1928 Maxim, was the first pumper in town. The firemen petitioned the Town each year for additional hydrants at the beach, hoping to have water available should a fire erupt at the rapidly growing beach area.

LANDING A TUNA. Wesley Moody describes this catch to the on-lookers in this early 1920s photo.

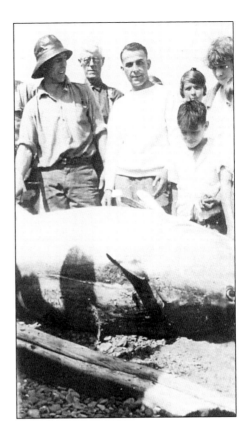

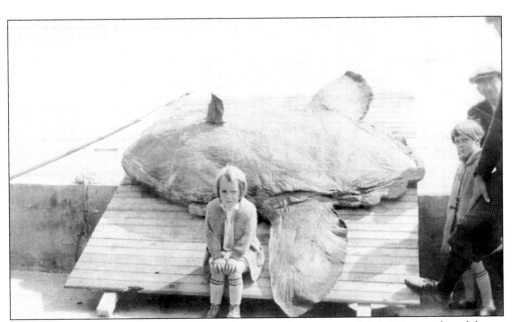

A SUNFISH CAUGHT AT FISHERMEN'S COVE. A rarity in these waters, this 2,000-pound sunfish was caught by Austin Guest in 1929. Here his daughter Marion poses with "the catch."

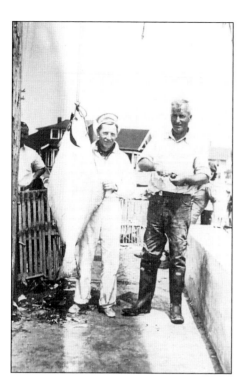

FISHERMEN WITH HALIBUT. Austin Guest (on the right) provided a fishing boat to accommodate visitors wishing to fish in Wells Bay. The man on the left is not identified.

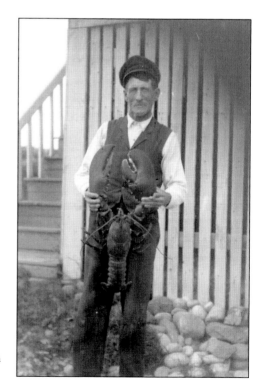

CATCH OF THE SEASON. Elmer Welch poses with a 12-pound lobster in 1906.

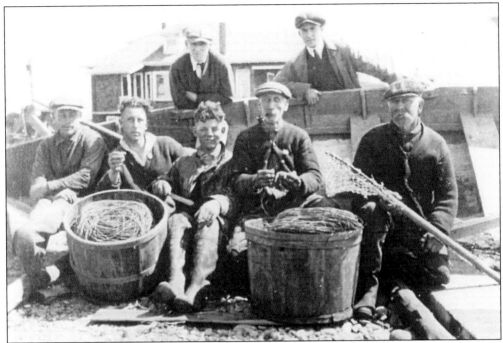

FISHERMEN AT THE COVE. This c. 1920s photo shows, from left to right, Geo. Prescott Moody, Wesley Moody, Charlie Kawalski, George W. Moody, and George Hatch. Frank L. Hatch and Nelson R. Kimball look on from behind the dory.

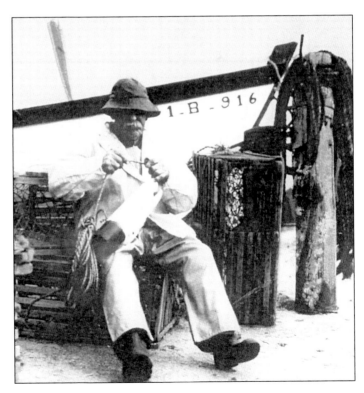

GEORGE HATCH. George donned his foul weather gear to pose in the late 1940s for a promotional brochure by the Old Wells-by-the-Sea Association.

THE EUGLEY FAMILY AT GAY COTTAGE AT COVE. Pictured in this 1906 photo are, from left to right, Harry Gay, Minnie Gay, Henry Eugley, Arthur R. Eugley Jr., Elizabeth and Phelps Eugley. The children are Harry, Minnie May, and the infant, Arthur.

COVE COTTAGES. On the 1891–92 Cadastral map, these buildings were noted as the Harvey cottages. In this 1906 photo, the cottage name is illegible. In later years, they were known as the Varney and Miller cottages and then the Woodbury and Graham.

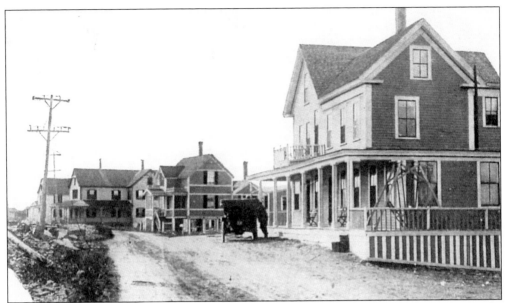

THE WEBHANNET HOUSE. Charles Chase Moulton Littlefield was known as the proprietor for many years of the Webhannet House, reportedly built by Samuel D. Littlefield.

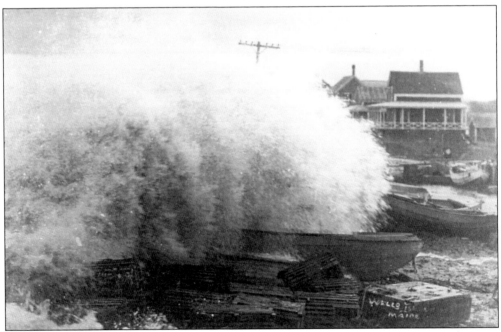

WILD SURF AT THE COVE. Storm-driven winds pour ocean surf onto the fishermen's dories in this image. Austin Guest's house is in the background. His family was one of the year-round residents of the area.

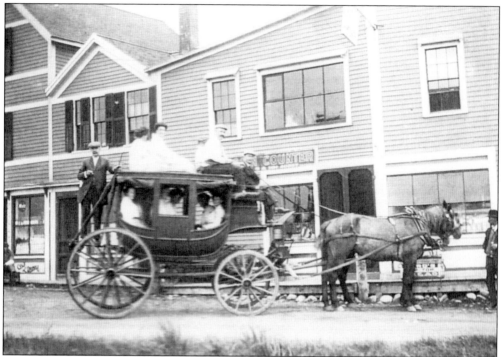

THE STAGECOACH TAXI. This 1910 photo shows the means of transportation used by the local visitors to reach their hotel, boardinghouse, or cottage. Automobiles were not yet readily available.

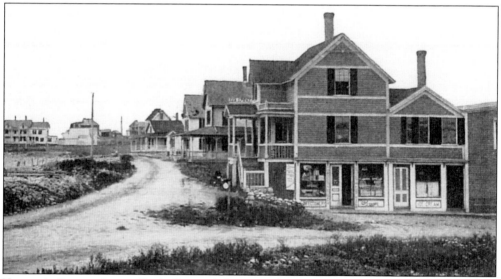

KIMBALL'S CORNER. Lester Kimball rented this store during the summer of 1907 and purchased it for his home and business in 1908. He sold groceries and was one of the first to advertise ice cream in 1917. The Wells Beach Hose Company was organized in Kimball's living room in 1910. He was also active in his church and community as well as being a photographer, historian, genealogist, and taxidermist. His writings and photographs have provided valuable insight into life in Wells during the first half of this century.

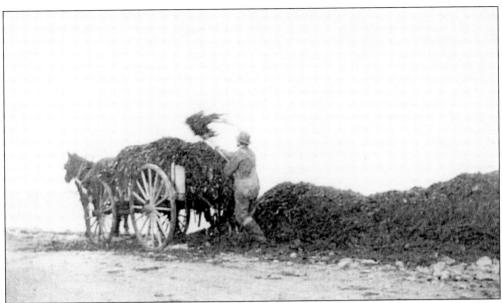

HARVESTING SEAWEED. Following a storm in January of 1933, an unidentified farmer fills his wagon with seaweed. Seaweed was also known as sea manure and was gathered to be used as fertilizer by nearly all the farmers.

OFF THE ROCKS. A lone fisherman hauls his lobster traps from his dory close to the ledges at Wells Beach.

THE BEACH FARM. This Eldridge Road farm, owned by Howard Ridley from 1908 to 1948, provided fresh produce, milk, and ice to the summer population for many years. His trucks made door-to-door deliveries. The farm included a large herd of registered Guernseys.

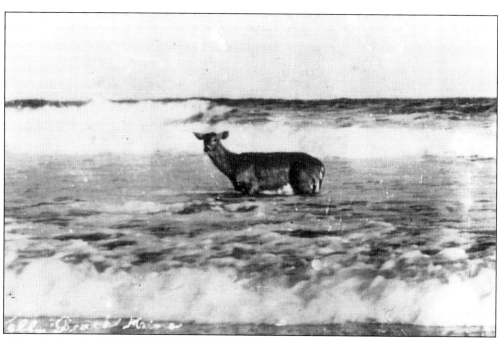

A DOE IN THE SURF. Deer might enter the surf if they are being chased by dogs or if there is a fire, etc. Leroy Nason captured this deer on film for his collection.

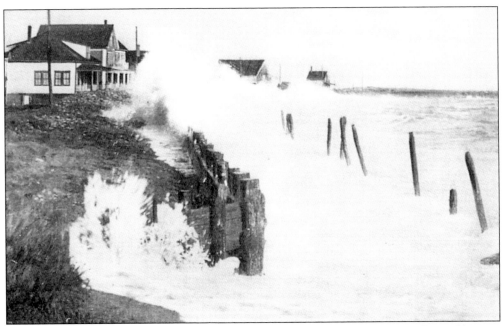

A STORM AT THE COVE. In this early postcard the seawall is only wooden posts. The Webhannet Post Office and Boarding House are at the left, and the George Hatch house is the last one visible on the right.

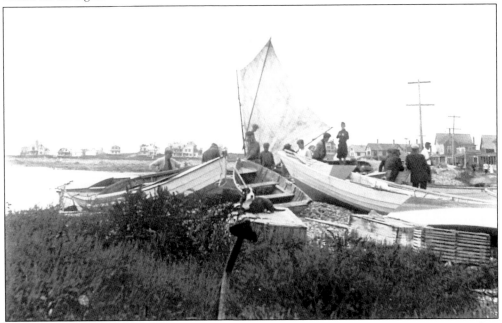

DORIES AT FISHERMEN'S COVE. The local fishermen used 16- and 18-foot dories with a sail to maneuver Wells Bay. Local resident and fisherman George W. Moody built many of these vessels. Vander Forbes Sr. recalls asking George to go fishing with him in the 1920s, and the next morning at 5 am, they went out. Trolling the ledges between the Casino and Cove, not out from shore more than 200 feet, Vander remembers catching three hundred pollock that morning.

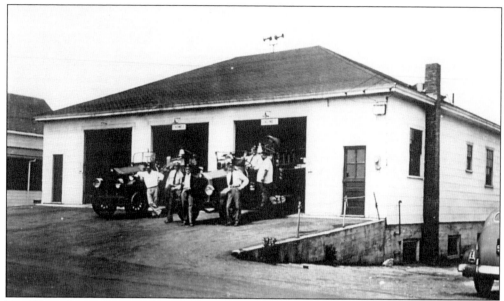

THE WELLS BEACH FIREHOUSE IN THE 1940S. Following World War II, the volunteers returned, and the Wells Beach Hose Co. resumed their annual field day, parade, and Firemen's Ball at the Casino. Engine 2 had been purchased from Kennebunk in 1946 and was rebuilt for use at the beach. From left to right are Gordon Bridges, Chief Donald Moody, President George W. Moody, Fred Fox, Joe Nickerson, and Harry Hatch.

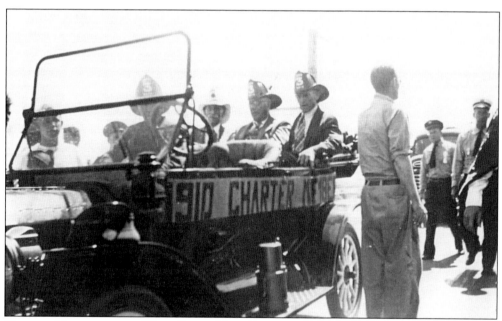

CHARTER MEMBERS OF THE WELLS BEACH HOSE COMPANY. Recognizing the 40th anniversary of the Wells Beach Hose Co. in 1950, the charter members rode in a Model T in the annual parade. In front is George Hatch, and in the back, from left to right, are George W. Moody, Harry Littlefield, and Lester Kimball. With their backs to photographer are, also from left to right, Frank Hatch, Fireman Bill Sevigney, and Chief Donald Moody.

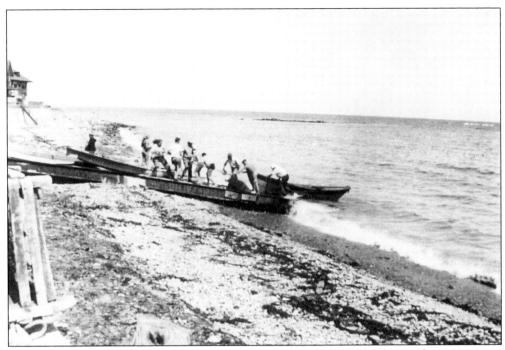

THE SLIP AT THE COVE. A winch was used in later years to pull the fishing boats ashore. However, here it would appear that man-power is accomplishing the task.

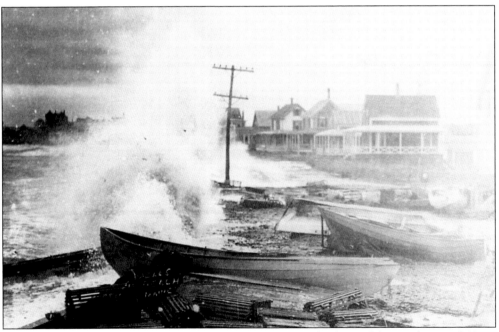

CASCADING SURF. A continuing spectacle at the Cove is the beautiful cascading surf. Year-round residents, such as Austin Guest, experienced it frequently. His house, at the right in this postcard, was known as the Lackawana and was moved to this location from Eldridge Road c. 1924.

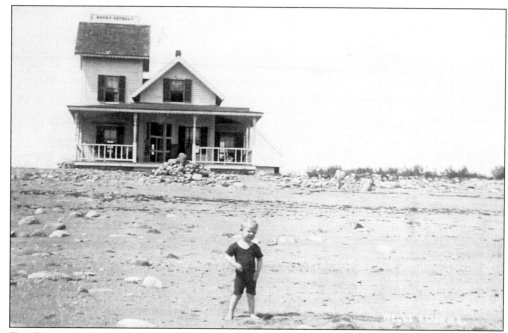

THE ROCKY RETREAT COTTAGE AT THE COVE. This 1908 postcard states that this is Lawrence in the foreground and Oliver is at the door. The card was addressed to a Pratt family, but it is unclear whether these are Pratt children.

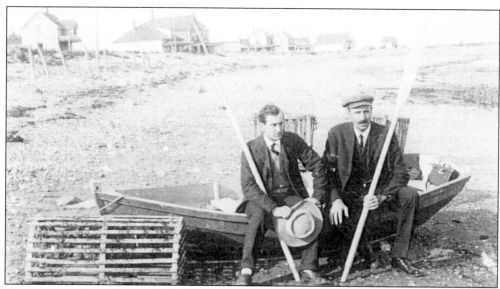

PREPARING TO ROW. Lester Kimball (left) and George Jacobs pose for a photo at the Cove. Lester's house, the Sea Spray, is at the left in the background with the Webhannet Post Office and Boarding House north of it.

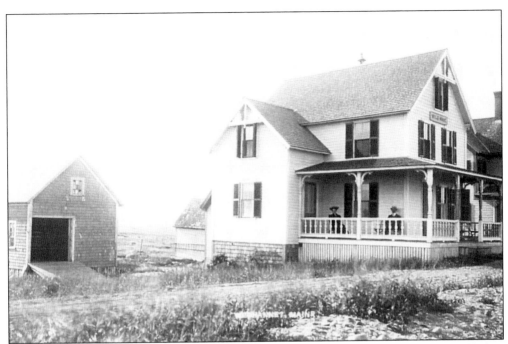

WILD WAVE COTTAGE. Located at Fishermen's Cove, this cottage still exists. The postcard below is taken just north of this location and one can well envision the source of its name.

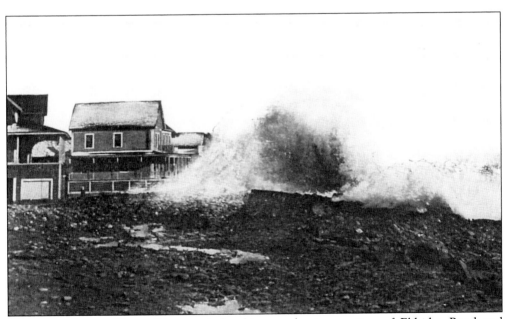

SURF IN A STORM. This wild wave is breaking at the intersection of Eldridge Road and Webhannet Drive.

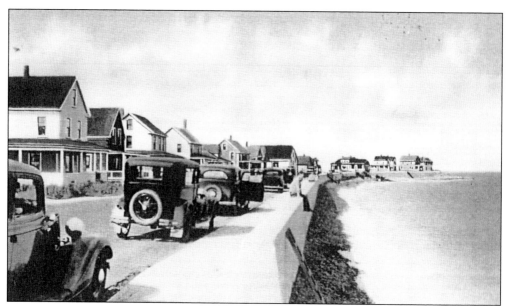

THE BREAKWATER AT THE COVE. In the late 1920s, a cement breakwater was installed to deter the onslaught of the stormy Atlantic. In this 1930s postcard it appears that folks have come to be cooled or just to watch the surf. This is one tradition that still continues today at this location.

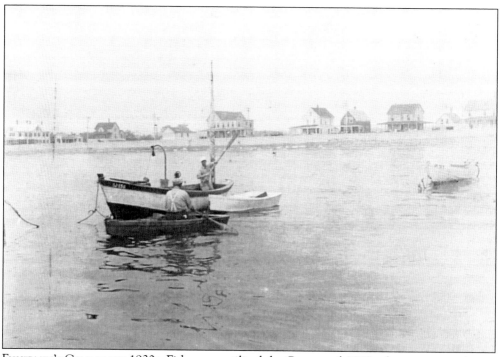

FISHERMEN'S COVE IN THE 1930s. Fishermen utilized the Cove until 1940, when a protected cove was dug in Ogunquit. Here, Raymond Hayes (with the oar) and Austin Guest in the punt are preparing to come ashore.

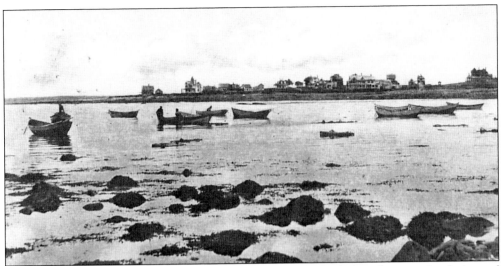

FISHING COVE. This 1912 postcard photo was taken from the ledges showing the dories and punts anchored in the Cove. The early fishermen had to keep a good weather eye focused while they fished in their little dories on the uncertain sea.

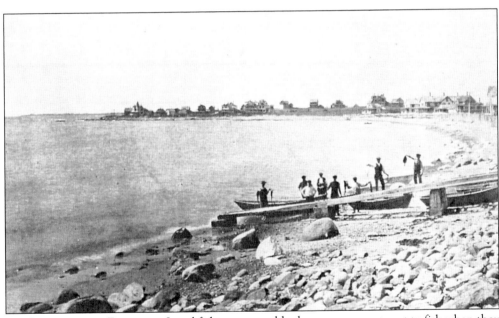

THE RETURN OF THE FISHERMEN. Local fishermen would take summer guests out to fish when they visited here. The point of land behind them is known as Moody's Point—today recognizing George W. Moody's six decades as a year-round resident. It has also been known in years past as the Neck, Fountain's, Thornton's, or Skipper's Point as designated on a variety of postcards during the first part of the century.

A FISHERMAN WITH HIS SON AND A FISH BARREL. Austin Guest's son Russell enjoys a ride in his father's wheelbarrow in this 1914 photo. They were at the intersection of Webhannet Drive and Eldridge Road.

SNOW AT THE BEACH. Yes, it does snow at the beach! Mabel and Lester Kimball stand in front of their Model A on Eldridge Road. Their home is behind them at the right (but cannot be seen here). Roads were rolled to pack the snow prior to the advent of snowplows.

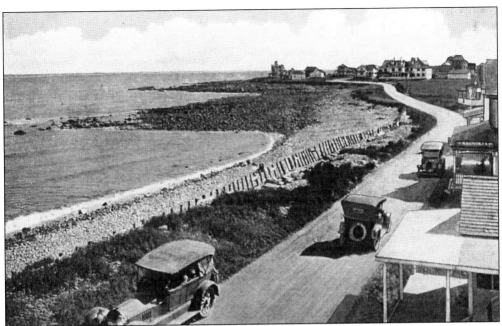

WEBHANNET LOOKING WEST. This 1910 postcard shows touring cars traveling along Webhannet Drive. Note the wooden stakes serving as the breakwater at this date.

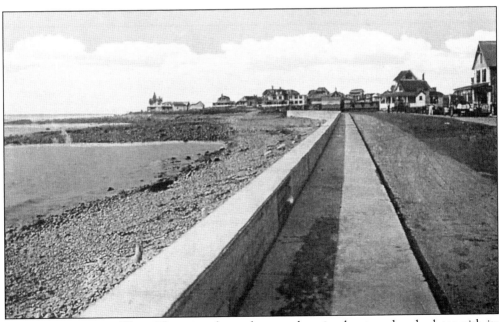

WEBHANNET LOOKING WEST. This view shows the same location but two decades later with its new cement seawall. Moody Point is in the background.

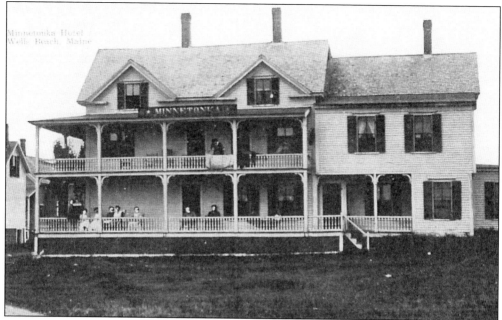

THE MINNETONKA HOTEL. This hotel was first advertised in the *Maine Atlas* of 1891–92. Built and managed originally by Aaron Perkins, it has had several names as owners changed. Previous names have been the Washington Hotel, All's Well Inn, and now the Grey Gull. Room and board during the 1890s was only $7 per week.

ABRAHAM'S CORNER. The location in this postcard was named for former owner Abraham Littlefield. This area has also been called the Neck in early deeds. The summer cottages shown here were owned by the Bugbees (far left), Dr. C. Horsch (in the middle; note the mansard roof), and the Perkins family (they rented out the cottages to the right). The only year-round residence was that of George W. Moody, partially obscured by the tree in front of the Bugbee cottage.

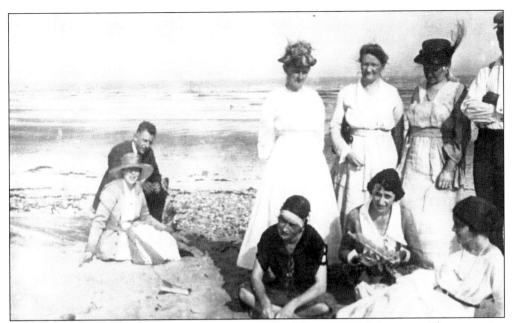

GUESTS FROM SOMERSWORTH. Annie Kimball, wife of the mayor of Somersworth, entertains friends at her Ocean Avenue Grand View Cottage and poses here with them at the nearby beach. She is the lady standing in the center of the photo.

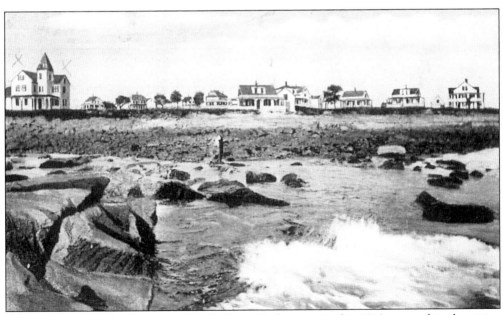

FOUNTAIN'S POINT. Now known as Moody Point, the location in this 1910 postcard is advertising the Fountain House as a rental (it is designated with two xs). Beyond the Fountain House, from left to right, the houses were owned by the Moody, Horsch, Kimball, Allen, Plummer, Bugbee, and Perkins (two in a row) families. The building to the far right is the Minnetonka House.

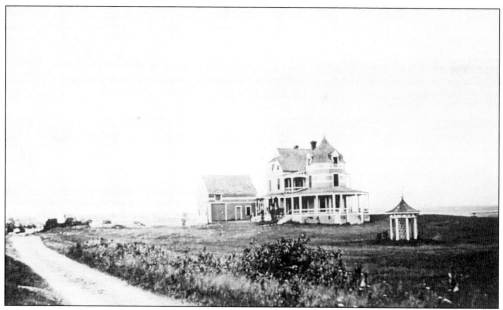

THE CASTLE. Designated by the locals as the Castle, this Queen Anne-style summer home with stable and gazebo at Moody Point was owned by the Whitehouse family. Grand summer balls were held here in the early 1900s. George Moody, apprenticed to a painter, worked on this at age twelve (1889–90). A decade later he would build his own home a few yards down the street.

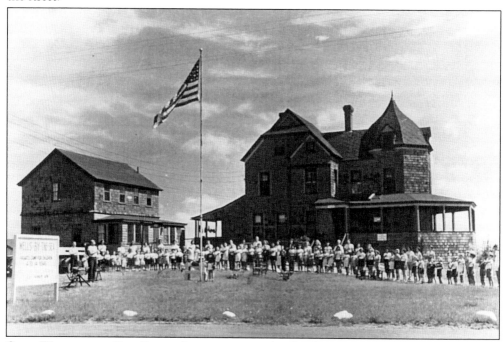

CAMP WELLS-BY-THE-SEA. Empty for many years, the Castle was purchased by Rev. William McCullough to use as a summer camp for youngsters from New York City, New Jersey, and Pennsylvania. The camp was in operation from 1946 until 1959. Developers had the local fire company burn it in 1963.

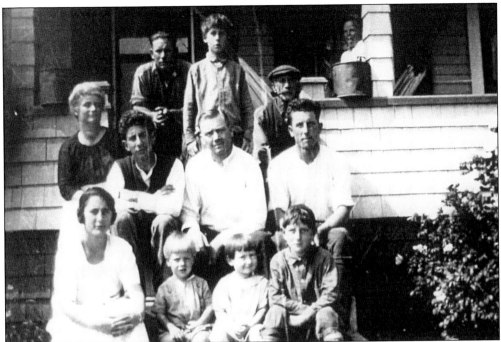

THE MOODY POINT MOODY FAMILY. George W. Moody built his home in 1902 and remained there until his death at age ninety-four in 1961. Here he poses in the early 1920s with his family, who are pictured from left to right: (front) Marion (Moody) Annis, Harold Annis, Ruth Annis, and Ernest Moody; (middle) Clifford Moody, A. Jack Annis, and Wesley Moody; (back) Lillian (York) Moody, Geo. Prescott Moody, Donald Moody, and George W. Moody.

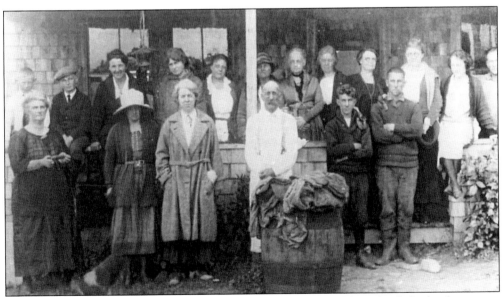

AN ANNUAL SUMMER CLAMBAKE. Each year George Moody would do a clambake for the visitors at Moody Point. Here folks pose on the porch of the Moodys' rental cottage in back of their home. His wife, Lillian, is at the left, and George stands behind the barrel. His sons, Clifford, Wesley and G. Prescott, are to the right of the barrel.

SALT WORKS AT MOODY POINT. During the Revolutionary War, salt could no longer be imported. Several locations in Wells utilized the rocky coast to collect salt from the seawater. Thirty bushels per week were derived from just one site.

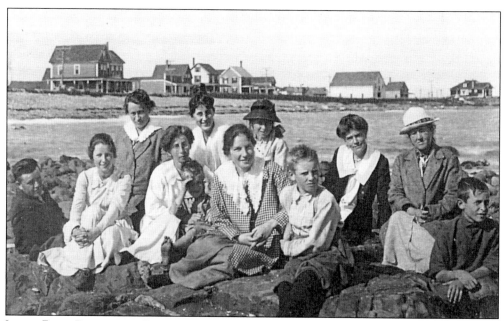

LOCAL FOLKS POSE ON THE ROCKS AT MOODY POINT. Lester Kimball captured in this photo his family and others who had worked at his store at the corner of Eldridge Road and Webhannet Drive. From left to right are Roy Flaker, Grace Pinkham, Cora M. Kimball, Mabel Kimball (holding Dwight), Marion Moody, Mabel Pinkham, Ruth Bates, Frank Hatch, Georgie Perkins, Annie Bates, and Nelson Kimball.

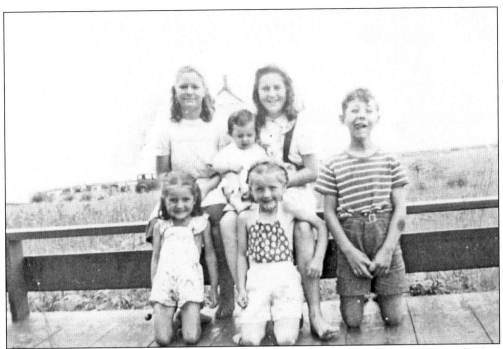

A SUMMER POSE. Local children at Moody Point took a moment for this photo in the late 1930s. They are, from left to right: (kneeling) Caroline Perkins, Nadyne McCarn, and Dickie Perkins; (seated) Ann Perkins and Justyne McCarn (holding Judy Perkins). The Perkins and McCarn families lived on the northeastern side of Highland Avenue at the Ocean Avenue intersection.

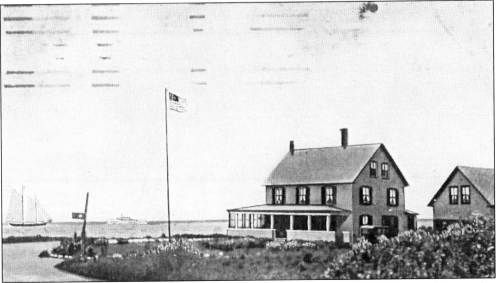

ROCKLEDGE. The Misses Mamlok were noted as proprietors in this late-1930s postcard. Located at the northeast corner of Ocean Avenue at Moody Point, Rockledge provided its guests with the opportunity to enjoy watching the seagoing traffic as well as the early autos. Locals remember the horizon being white with sails. This building was torn down and replaced with a private residence during the 1990s.

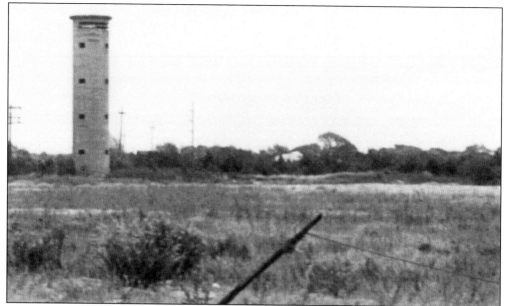

An Observation Tower Turned Lighthouse. During World War II, the Coast Guard built observation towers and bunkers all along the East Coast. At a later date, when it became part of Camp Wells-by-the-Sea, a function room/dormitory was added to the ocean side. It was also briefly used as a restaurant at its Moody Point location. Although inland, the Garnsey Real Estate Office's Lighthouse now provides an ingenious disguise to the former gray cement tower.

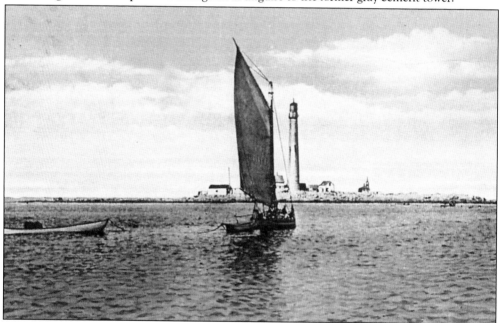

The Boon Island Light. This lighthouse can be seen from Moody Point and our beaches. Located 6.5 miles off the coast, the tower of the Boon Island Lighthouse is the tallest of any on the Maine coast at 137 feet. Its 70,000-candlepower light can be seen for 18 miles. This lighthouse was built in 1852, but three previous ones had been built on its site in 1780, 1805, and 1811. This light was made famous by Kenneth Roberts' book of that name.

Three

MOODY BEACH

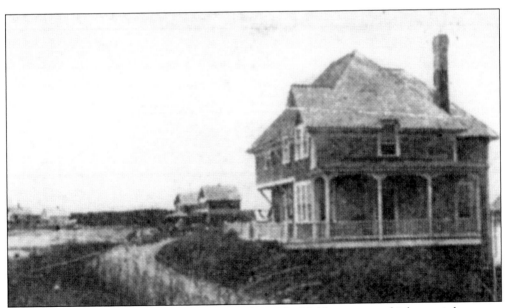

THE HOBBS COTTAGE. This early-1900s photo shows the Hobbs cottage, which now is known as the Matthews. The two Varney cottages and the two Iovine cottages are located farther down the beach. Note the road which passes in front of the cottages.

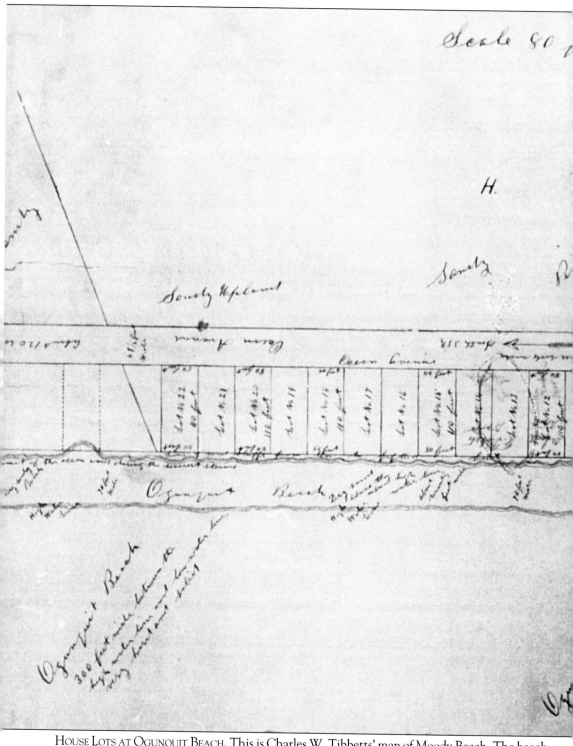

HOUSE LOTS AT OGUNQUIT BEACH. This is Charles W. Tibbetts' map of Moody Beach. The beach was called Ogunquit Beach at the turn of the century because (oddly enough) it was the beach leading to Ogunquit. Mr. Tibbetts' publicity on the map states that "there is 300' between high

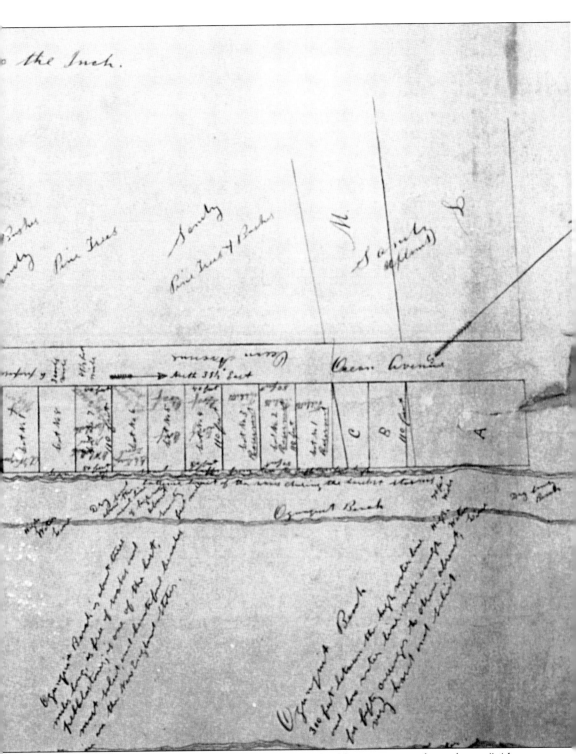

and low water line—very hard and solid—wide enough for fifty carriages to drive abreast." Also noted on the map is that the beach "is about 3 miles long—free of rocks and pebbles—one of the best, most select and beautiful beaches in the New England states."

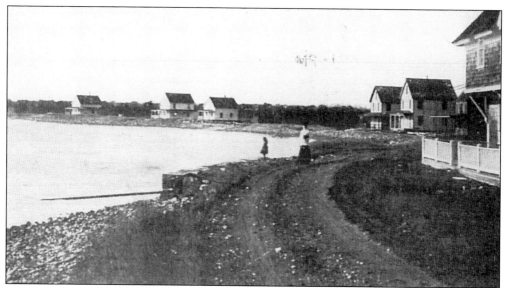

Moody Beach, 1913. A lone girl stands beside the wider road. During the Model T era the George W. Moody family parked their car here during the winter months. Keeping the battery and oil by the stove, they replaced that and the water for a weekly drive along the beach to Ogunquit for groceries. Snow prevented travel by road, so the beach at low tide provided a necessary highway.

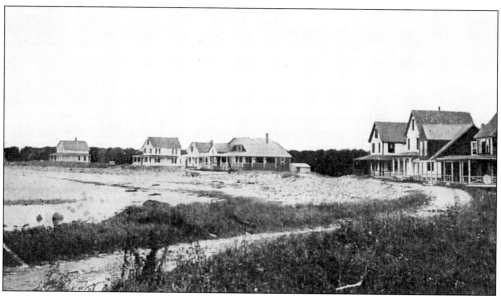

Moody Beach, 1914. A few more cottages have been added to the landscape. The road is shown here going in front of the cottages as far as the first right-of-way of today.

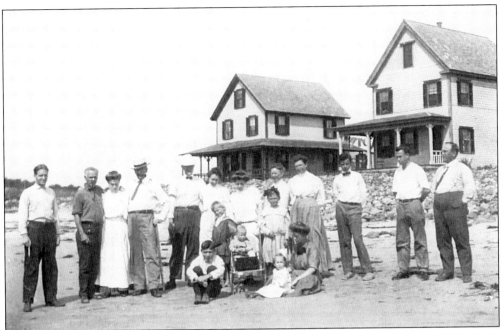

VARNEY COTTAGES, 1908. It is unknown whether these people are members of the Varney family or if they were just visitors in front of the cottages. The cottages were built *c.* 1900 and are known today as the Elizabeth Grace and Arline.

THE RUBBISH BRIGADE. The rubbish of early years was buried in the sand at low tide. The Furbish Road was known as Garbage Road to the summer folk. At high tide garbage was thrown into the river to be carried away. The gulls obviously wouldn't allow much to go far. By 1923 the Wells Board of Health decreed that all rubbish should be burned, buried, or otherwise disposed of so as not to be menace to the health of the residents of the beach.

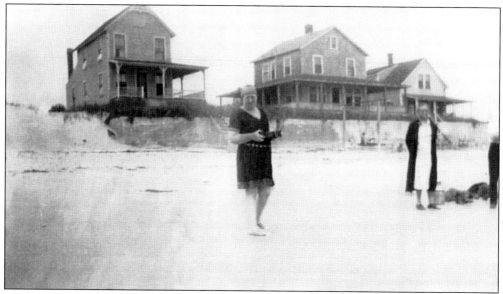

Moody Beach in the 1920s. An unknown bather and perhaps strollers are pause to have their picture taken. Eight decades later, strollers are still enjoying the walk along the beach.

The Hall Cottage. Originally built by Mrs. Iovine in 1906, this cottage and three lots were purchased by Walter and Grace Hall of Melrose, Massachusetts, in 1921. George W. Moody & Sons remodeled and updated it for them. In 1926 Walter came for the holiday on April 19 with a business friend from the West Coast who wanted to see the Atlantic Ocean and snow. The ground was bare when they retired, but a blizzard during the night made huge snow drifts. Luckily, the Moodys had seen the smoke from Walter's wood stove and came to shovel away the drifts, making the basement, wood, and shovels accessible.

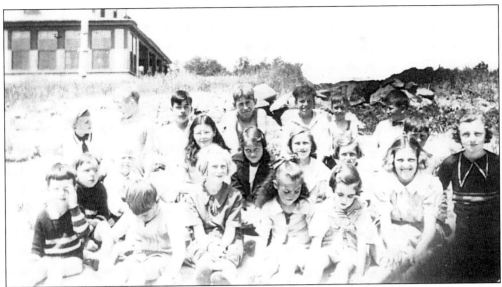

A MOODY BEACH PICNIC, 1935. Teacher Mary Hall's Division 1 students are, from left to right, as follows: (front row) Earl Smith, Myles Hill, Mildred Hill, Helen Strickland, Frances McLaughlin, Mary Lord, and Marguerite Collins; (middle row) Elmer Smith, Henry Eaton, Josephine Eaton, Annie Eaton, Constance Campbell, Muriel Campbell, and Kenneth Campbell; (back row) Richard Tobey, Alden Smith, Valerien Cliche, Woodrow Strickland, James Strickland, Charles Smith, and Melvin Campbell.

THE MARTIN COTTAGE. This cottage was built c. 1908 by Joshua Martin of Manchester, New Hampshire. It is one of the few cottages to retain its original style and landscape. Five or six generations of this family have enjoyed summers here.

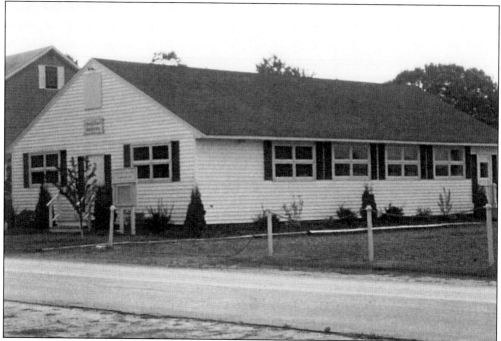

THE MOODY BEACH ASSOCIATION BUILDING. Although active for many years the Moody Beach Association did not officially organize until 1955. Their Community Building located on Furbish Road was completed in 1958.

PINES AT THE END OF FURBISH ROAD. For generations, local families would enjoy picnics here in the shade. They came to the beach to be cooled by the sea breeze or for a swim. Furbish Road was accepted as a town road in 1910 and described then as going from Post Road over the old Furbish Road to the top of the sand hummock—two rods wide and 4,448 feet long.

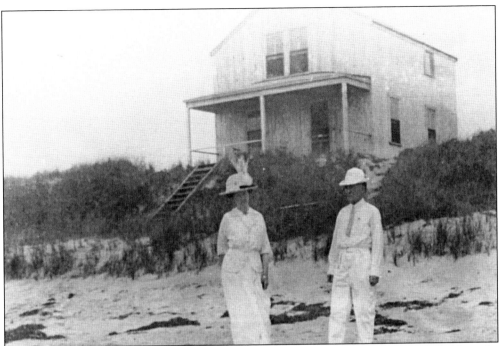

THE KIMBALL COTTAGE. This cottage was built in 1913 by Harry and Alma Kimball. Note the dune grass surrounding it.

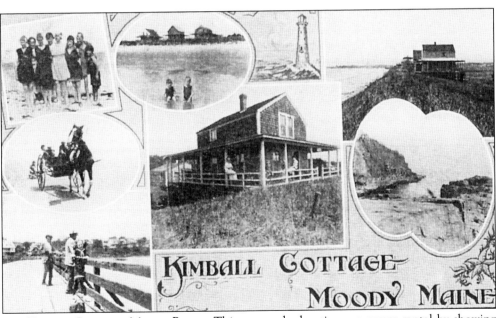

THE KIMBALL COTTAGE, MOODY BEACH. This postcard advertises a summer rental by showing a variety of scenes along the beach. The postcard describes the place as being located on the sand dunes at Ogunquit Beach and commanding a wide view of the ocean. Rooms were let with full kitchen and dining room privileges. As was customary for beach rentals, all persons were expected to bring their own bed and table linens as well as their silver.

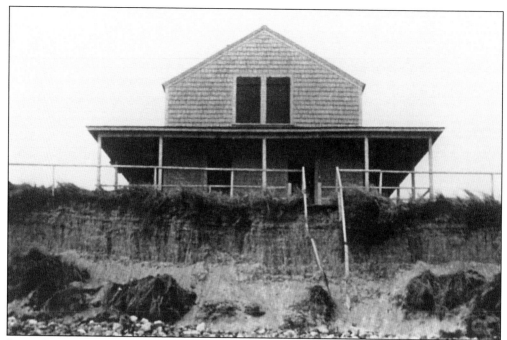

BEACH EROSION. Storms have taken their toll at Moody Beach also. This shows the washout in front of the Kimball Cottage following the March 15, 1931 storm.

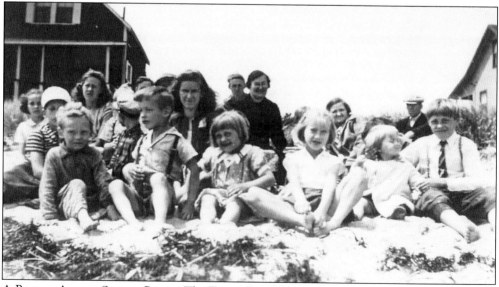

A BOURNE AVENUE SCHOOL PICNIC. The Tatnic Road Division 6 School picnicked here in June 1941. Bertha Bourne, their teacher, took this picture. The children are, from left to right: (front row) Fred Welch, Percy Stevens, Hilma Stevens, Thelma Stevens, Lois Stevens, and Harold Stevens; (back row) Bertha Stevens, George Welch, Hazel Stevens, Myrtle Stevens, unknown, Alma Stevens, Evelyn Stevens, and John Stevens.

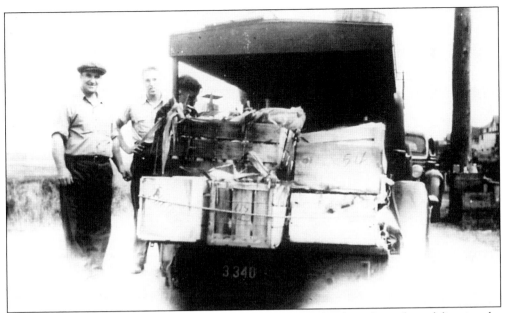

DELIVERING SUMMER PRODUCE. Leon Goodwin and his son Richard are shown here delivering the produce grown at their Post Road farm called Shady Nook.

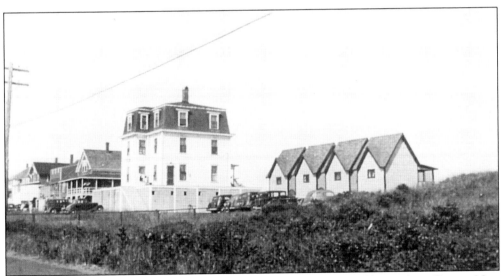

THE MARSHVIEW. This was the home of developer Charles W. Tibbetts, from Dover, New Hampshire, originally. More recently, the Bill Shapleigh family has summered here. The cabins were built in the 1920s, when they became popular for the traveling public. The cabins have been replaced by two cottages.

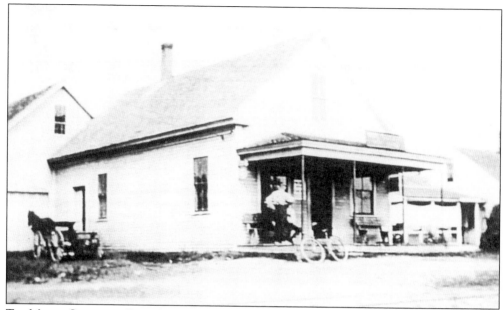

THE MOODY STORE AND POST OFFICE. Various modes of transportation are visible here: a bicycle, horse-drawn buggy, and the rails of the electric cars (in the lower right-hand corner). From 1907 to 1923 the Atlantic Shore Line had a car stop here. The stop for the beach at Moodys' Store and Post Office led to naming the beach "Moody."

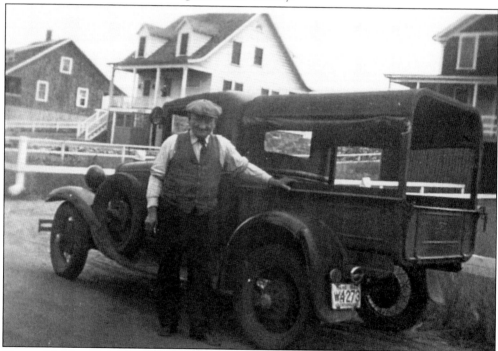

GEORGE H. MOODY. A cousin of George W. of Moody Point, George H. operated Moody Store and was Moody's postmaster. He would take and deliver grocery orders to the beach. Here he stands by his delivery truck with the white Ocalem cottage in the background. The Lembree family had named the cottage after their sons, Oscar, Albert, and Emil.

BOURNE AVENUE. In March of 1892 by the petition of Jonathan A. Bourn and others, the town of Wells voted to accept a new town way from Varrell's Store (later Moody's) to the beach over the lands of J.A. Bourn, George W. Littlefield, and C.W. Tibbetts.

ELSIE LITTLEFIELD, C. 1927. Elsie is seated on the bank of the river on the south side of Bourne Avenue. Reportedly the Tibbetts' cottages are in the background. Elsie's husband, Everett Littlefield, built Shorey's Lodge for a Tibbetts' daughter. Elsie and Everett also delivered fresh produce to the summer folks at the beach.

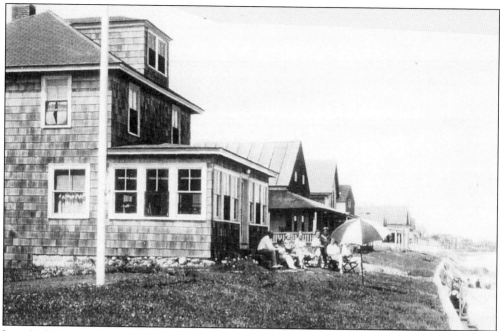

LORD'S TOURIST HOME. Harry Lord was a plumber. His wife ran this rooming house at the beach.

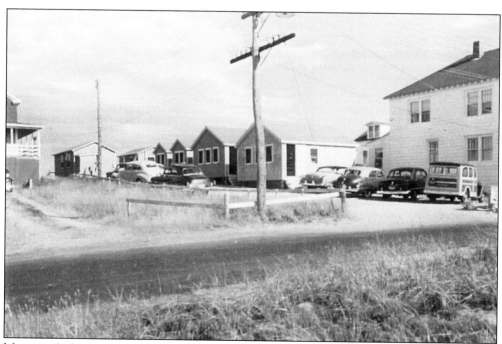

MARSHALL'S CABINS. This c. 1950s postcard advertises rental cabins on the beach south of the Bourne Avenue intersection.

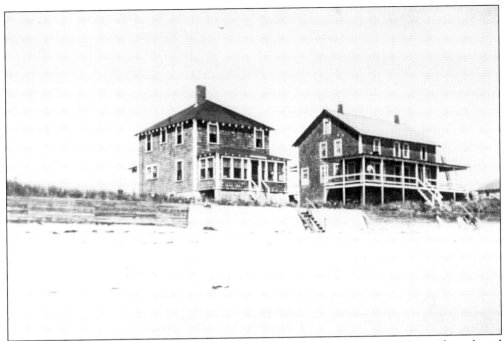

THE REST HAVEN COTTAGE. The Rest Haven cottage was built in the late 1920s and purchased by the Fisher family in 1945. To the right is the Jordan-Fellows cottage, which was perhaps the only duplex built on the ocean front at this time.

THE FISHERS ENJOYING THEIR BEACH COTTAGE. Raymond and Laurette Fisher were perhaps celebrating the end of World War II in this August 1945 photo.

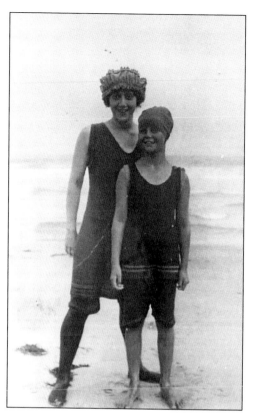

A Day at the Beach. Eva Day (left) and Mary Hall are enjoying a day on the beach. The sea is very placid behind them. Mary's grandmother was very disturbed when her son purchased Moody Beach property. It seems the rumors were that the waves were much higher and the undertow much stronger at Moody than at other Wells beaches.

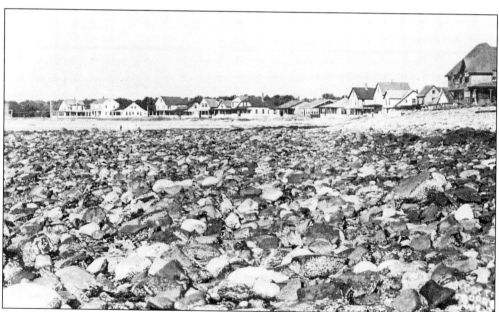

A View of Cottages and Rocks from Moody Point. This 1940 postcard shows the upper end of Moody Beach. It has been noted that Charles Tibbetts was quite disillusioned the first time he experienced the winter erosion of sand which exposed all the rocks on his supposedly sandy beach. Little did he realize that the spring storms would return the sand.

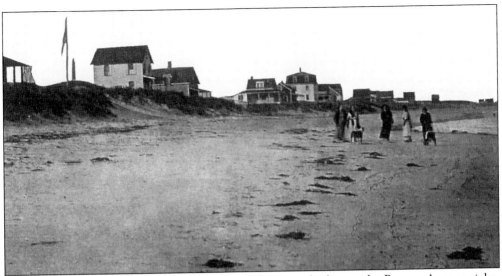

LOOKING NORTH ALONG MOODY BEACH. This 1912 postcard taken at the Bourne Avenue right-of-way shows not only people, but dogs and babies in carriages. Note the height of the barrier dunes covered with grass. There were reportedly nineteen cottages on Moody Beach in 1912.

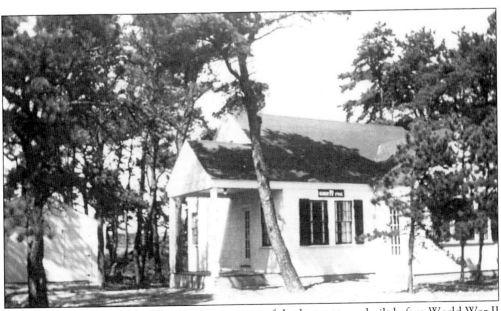

THE KNOTTY PINE COTTAGE. This cottage was one of the last cottages built before World War II on the west side of Ocean Avenue. Carroll and Bess Brooks of Springvale hired Wesley Moody to build it. They also owned rental cottages on the waterfront. Today this cottage has been raised and is known as the Lea Rose.

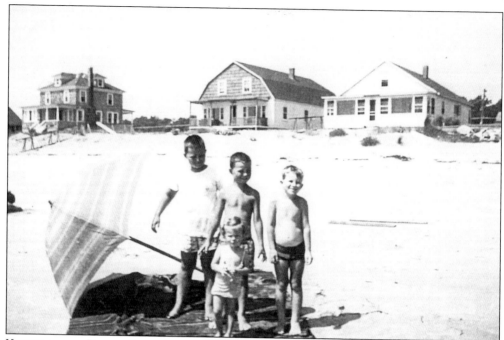

KIDDIES AT THE BEACH. Several generations of many families continue to play in the sands of the beaches of Wells. Shown here are, from left to right, David Luce, Dick Luce, and Henry Hall, with Mary Ann Hall in front, enjoying the sunshine *c.* 1950 at Moody Beach. In the background are the Nickerson, Dunsmore, and Muir cottages.

SAND DUNES AND THE SEA. The dunes provided the foundations for summer cottages during this century. But prior to that during the age of sail, sand-lighters (shallow-drafted schooners) carried sand from local beaches to Boston. The fine quality of our white sand made excellent building mortar and brought a good price. Reportedly the old Jordan Marsh and Filenes stores in Boston were built from the sands of Wells.